IN OLD PHOTOG

BRITA

AROUND
BURY ST EDMUNDS

ROBERT HALLIDAY

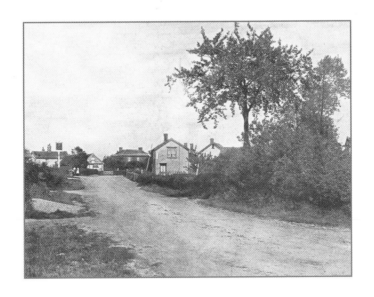

SUTTON PUBLISHING

Sutton Publishing Limited
Phoenix Mill · Thrupp · Stroud
Gloucestershire · GL5 2BU

First published 2004

Title page photograph: Brockley village green, facing east. The sign of the now closed Six Bells pub can be seen to the left. This road has become overgrown and is now a footpath. (*Pawsey*)

British Library Cataloguing in Publication Data
A catalogue record for this book is available from the British Library.

ISBN 0-7509-3453-0

Typeset in 10.5/13.5 Photina.
Typesetting and origination by
Sutton Publishing Limited.
Printed and bound in England by
J.H. Haynes & Co. Ltd, Sparkford.

This book is dedicated to the memory of my father,
Owen Arthur Halliday (1915–2003)
who encouraged my interest in the world around me,
and gave me the desire to understand.

CONTENTS

ACKNOWLEDGEMENTS

Some of the photographs and postcards reproduced in this book come from my own collection, but I have been helped immensely by the following people who have made pictures available to me from their collections: Bowers Motorcycles, Risbygate Street, Bury St Edmunds; Jennifer Cordeaux; John Cullum; Barrie Fordham and Fordham's Garage, Ixworth; Darran Green; N.W. and P. Rogers' Garage, Whiting Street, Bury St Edmunds; St Edmundsbury Borough Council Museums; Mr and Mrs J. Smith of Ashley; Suffolk Jewellery and Antiques, St John's Street, Bury St Edmunds; Joe Wakerley and the Bury Bookshop, Hatter Street, Bury St Edmunds; Frank Whitnall; and Edward Wortley. Except where other individuals are credited, I am extremely grateful to F.G Pawsey's grandson, Bob Pawsey, for the use of photographs and cards credited to Pawsey.

Thanks are also due to Maisie Boreham, David Hardy, Jeremy Hobson, Don Miller, Susan Reeve (and family), Gill Shepstone, David and Margaret Slade, and Adriana Sascombe-Welles for help in the preparation of this book.

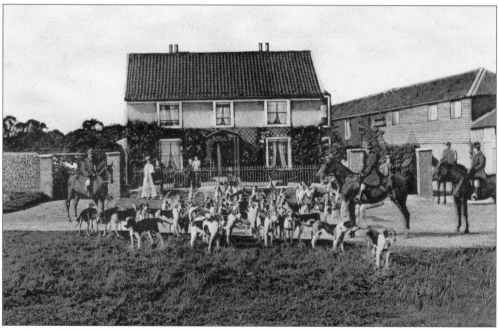

The Suffolk Foxhounds on Barrow village green. In 1906 (the postmark date) the Suffolk hunt kept twenty-five pairs of hounds in kennels in Bury St Edmunds. Published by W.T. Barton, the village newsagent. (*Joe Wakerley, Bury Bookshop*)

INTRODUCTION

Bury St Edmunds and the villages surrounding it have seen dramatic change in the past century. This book shows some scenes from the drama. Yet it would be wrong to think that the area experienced little change in the centuries before the invention of photography. Even a brief investigation shows incredible change in the past two thousand years, mostly the result of human activity. There is no truly natural landscape left here: even rivers and streams have been diverted to irrigate the land or to facilitate transport.

People have lived in Suffolk since prehistoric times. There are many archaeological traces of Roman activity in the area (as shown at Stanton). But 'Suffolk', the land of the South Folk of the Eastern Angles, is an Anglo-Saxon name, as are the names of the towns and villages in the area, and there is controversy as to whether the Anglo-Saxons settled the region afresh, or took over pre-existing settlements and agricultural systems.*

The Domesday Book, compiled at William the Conqueror's command in 1086, is particularly thorough for Suffolk. By then nearly all the towns and villages featured in this book were well-established communities, and there were at least 418 churches in the county. Many churches have since been rebuilt or remodelled (the fourteenth, fifteenth and early sixteenth centuries saw ambitious rebuilding campaigns) but they are still the most obviously historic buildings in many villages. They have been continually adapted and altered to provide a record of local aspirations: many significant events in local history are commemorated in rural churches.

Situated in a fertile agricultural region, with good communications to the rest of England, the area enjoyed great prosperity in the Middle Ages and on into Tudor and Stuart times. This is reflected in the vernacular architecture, and the many excellent houses of the fifteenth, sixteenth, seventeenth and eighteenth centuries.

The upper classes left their mark on the area by building great country mansions. This was followed by the development of the estate village, such as those at Euston, Great Barton and Cavenham. These are unlike most country villages: buildings have normally been planned to unified designs, and are often of higher quality than would be expected. In other cases, such as Ickworth, Fornham St Genevieve and Little Livermere, villages were removed to enlarge the Lord of the Manor's park.

* It is thought that the Anglo-Saxon kingdom of East Anglia extended as far as the Devil's Dyke, a long earthwork west of Newmarket, so some of the Cambridgeshire villages shown here may have formed part of early Suffolk.

(It should be emphasised that the lord nearly always provided villagers with new homes: after all he made money from renting houses, and he needed servants and workers to maintain his house and estates.) It would be impossible to generalise as to whether the country squires were good or bad: some exploited their tenants and servants; others were benevolent, building high-class cottages for their tenants, and funding village amenities. The Martineau family demonstrated one ideal of this form of social organisation when they had model cottages built at Walsham le Willows.

Until the mid-twentieth century the regional economy was largely agricultural. Most people were employed in agriculture: even the upper classes derived much wealth from ownership of agricultural land, while industries such as brewing, food production and cloth manufacture were derived from agricultural production. The Industrial Revolution of the eighteenth century did not have the same impact on the area as it did on parts of Yorkshire or Lancashire but its effects were felt none the less. In the late eighteenth century six turnpike roads crossed the area (five converging on Bury St Edmunds) improving transport and communications, and some people were aware of the novelty of the Industrial Revolution, even if they did not utilise its awesome potential: there is a tradition that the world's second oldest iron bridge was built in Culford Park. The railways effected significant change: in 1846 a railway line connected Bury St Edmunds with Ipswich (and London); this was extended to Newmarket and Cambridge in 1854. Smaller lines from Bury to Long Melford and Thetford followed. Railways did not just improve trade and communication: they also allowed people to seek better prospects in London and the industrial regions. It may not have been coincidental that Suffolk's population fell between the 1851 and 1861 censuses.

The Agricultural Revolution effected a more subtle change, as new ideas and technology brought radical change to farming. From the mid-nineteenth century the mechanisation of agriculture accelerated, while population expansion stimulated demand for food, and improved roads and railways allowed produce to be transported.

Another change took place in education. From the sixteenth century philanthropic public figures might have established village schools (as at Ampton): by 1833 about 20 per cent of Suffolk children were receiving some form of elementary education. After this state aid became available for education, and after 1870, by which time about 60 per cent of rural children were acquiring some formal teaching, the Forster Act made primary education compulsory, and schools were built in most villages.

A national agricultural depression started in 1879, and its effects were felt until the 1930s. Prices fell, and cheap food began to be imported from abroad. Farming profits fell and agricultural wages declined. Village wind and water mills found it increasingly difficult to compete with factory-milled flour. The effects could be seen in village life, and many people were still living in little better than slum conditions in villages, even in the 1930s. (My father, born in Ashley in 1915, remembered local houses that had dirt floors.)

Even so, there were opportunities for people with ambition. (And with compulsory education people could acquire some knowledge of the wider world.) Great efforts were made to bring new stimulation to village life: reading rooms were established, sporting clubs (such as cricket teams) were formed, and Women's Institutes began to

meet. Village halls were built to form communal meeting places. The creation of parish councils in 1894 started experiments in village democracy which continue to this day.

The army, too, offered an opportunity for men with a spirit of adventure (or desperation) to escape rural life. The First World War had a great impact on the region, when young men from every town and village left their homes to fight in a war as big as the world: the Suffolk Regiment was expanded from two to twenty-seven battalions. One obvious change to most village landscapes after 1918 would be a war memorial. Survivors had been uprooted and dragged into a new alien environment, permanently changing their perspective on life. The industrialisation and mechanisation of society that accompanied the war ensured that rural England would never be the same again.

Even while the First World War was in progress, it was realised that people might not be happy with tumbledown old houses, and the first council houses began to be built. Other dwellings designed from blueprint plans were made for people whose prosperity and expectations were expanding.

The continued development of the petrol engine changed travel, and farmers made increasing use of tractors. It is not coincidental that many blacksmiths' shops became garages.

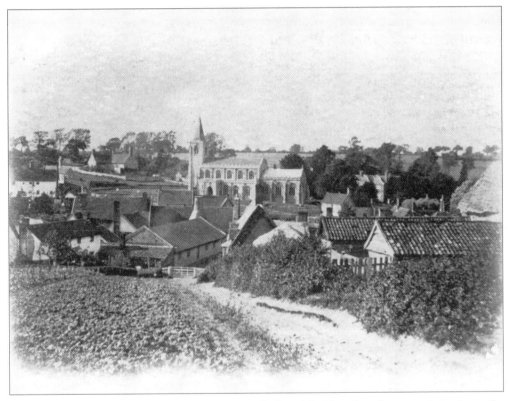

Rattlesden from the south, on a card postmarked 1904. The church tower dates from the fourteenth century: parishioners' wills suggest that the rest of the structure was being built in the 1470s. (*Pawsey: author's collection*)

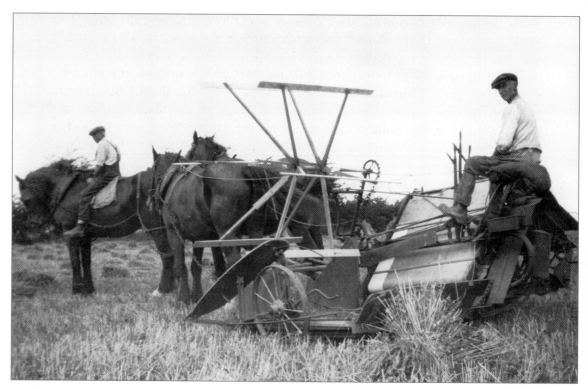

Members of the Seymour family harvesting barley with binders at Valley Farm in Bradfield St George. Taken at about the time of the Second World War, these photographs show the final stages of the change from horses to tractors in agriculture. (*Joe Wakerley, Bury Bookshop*)

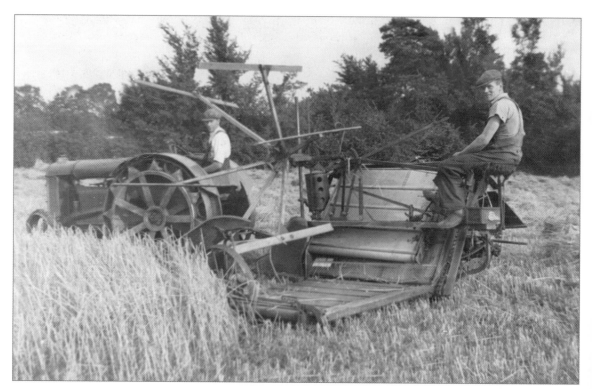

The Second World War caused further dramatic change as another generation was called away to fight abroad. The mechanisation and reorganisation of society that accompanied (and followed) the conflict had far-reaching effects. But not only was there the technology to build new houses: there was now a class of people who demanded higher living standards. Since then people's aspirations have grown exponentially. The growth of population, the demands for better housing, and the continuing use of the motorcar stimulated great change. Throughout the 1960s 2,000 new houses were built in West Suffolk every year. Many old houses were demolished or replaced in a desire to improve living conditions: other old houses were neglected until they either fell down or had to be demolished.

At the start of the twenty-first century many people still live in villages, but few work on the land. This is not just from choice. In 1900 a harvest might have provided employment for every villager who wanted work: now a single ·combine harvester might do the work of a hundred people in a day. Many country dwellers commute to work in a nearby town. Small shopkeepers are finding it increasingly hard to compete with supermarkets, or keep pace with the modern economy, and the loss of the village shop is a marked feature of village life. A relative decline in the birthrate and a rationalisation of the national education system has meant that many rural schools have closed, as children now attend larger, centrally placed institutes.

Another striking change is the decline of the country house. By the 1920s these were becoming increasingly expensive to maintain. (It was also becoming increasingly difficult to employ servants.) Many country houses have since been demolished, their contents destroyed and the parkland that surrounded them turned over to agriculture or building.

Changing attitudes to religion have left their mark on village life. During the nineteenth century Nonconformity was a strong force in rural East Anglia. Most villages had at least one chapel for the Methodists, Baptists or another denomination. Many of these now find it difficult to maintain congregations, and have closed (although some thrive, having adapted to changing needs). Medieval parish churches have escaped the worst excesses of modern development. Though their congregations may have dwindled, their historic and architectural importance has generally been recognised, and most (although not quite all) have been preserved, and are often well maintained, while new furniture and ornaments are being installed (even if churchyards are often deprived of historic and symbolic features by misguided landscaping and the removal of gravestones).

There should not be false nostalgia for a lost way of life. These photographs chronicle many changes, but they are not all necessarily for the worse. As late as 1951 a third of rural Suffolk houses lacked any kind of WC and a quarter of houses had no piped water. One photograph in this book shows a stream in the village high street that was used as a communal drain. This village now has modern sanitation. How many people would want to draw all their water from an outside well or use an outside privy? The closure of rural railway stations is often lamented, but this took place because more people now drive motorcars, which are in some ways more convenient than railway trains. (I would have been unable to write this book without use of a car!)

Even so, the loss of many historic buildings has deprived us of much that was beautiful or attractive. Until the nineteenth century houses were usually made from stones, bricks, timber and other materials of local origin, and they maintained an organic connection with the landscape. Many buildings shown here, such as windmills, watermills and blacksmiths' shops, were strictly functional and were designed for a specific purpose. Even if they had not been built with artistic principles in mind, they fulfilled their purpose admirably according to the requirements of the time, and displayed distinct aesthetic qualities. But by Victorian times builders were beginning to erect whole streets of new houses using materials transported from brick and cement works, and most modern houses are now made from pre-manufactured components.

Photographs alone cannot clearly illustrate other changes to village life. People may live in villages but they often work and even socialise elsewhere. In some cases a pub may be the centre of village life. Other villages maintain a focus: staging social events and maintaining communal amenities. Some villages are strong organic units, with a clear architectural, geographical and symbolic centre and spirit. Bury St Edmunds may be perceived by some as a little picture postcard town, but it is also an industrial centre, with many of the new service industries that have proliferated in recent years.

If this area is to retain a distinct identity, it will do so by confronting and adapting to the modern world while remaining conscious of its distinct historical and environmental characteristics.

There is growing recognition of the value of Suffolk's heritage. There are more preservation and conservation societies in existence, and more archaeologists investigating the distant (and recent) past, than ever before. Local history societies encourage an appreciation of local identity. Voluntary organisations work to preserve and maintain the natural environment. Planning regulations may restrict and stifle development, but they have also led to the preservation of old buildings, and have conserved some parts of the environment. Although the squirearchy may not return to the country mansion, many surviving country houses are finding alternative uses, or even being preserved for their historic, architectural and artistic qualities. It would be wrong to be complacent: the environment still faces many threats, but if people maintain an active interest it may be possible to save what remains of the region's heritage for a worthwhile future.

FEATURED PHOTOGRAPHERS

Frederick Pawsey

Frederick George Pawsey was born in Bury St Edmunds in 1870. When only 15 he took over a printer's and stationer's business in Bury St Edmunds. A Mr Langhorn invested in his business from 1892 to 1900, resulting in a company name change to Langhorn, Pawsey and Co. until 1906. Another change of name to Pawsey, Wright and Co. Ltd occurred between 1932 and 1936 when a Samuel Wright injected capital during the Depression.

Frederick Pawsey began publishing postcards in 1903, sometimes using earlier photographs. In 1907 he published *West Suffolk Illustrated*, a local guidebook, in cooperation with Horace Barker, the curator of Moyse's Hall (the Bury St Edmunds museum). Appearing as a serial part work, which customers returned for binding, this was a highly acclaimed and very popular publication, with photographs of every town and village in the region (many later reprinted as postcards). A companion volume, *East Suffolk Illustrated*, followed in 1908. The year 1907 was also marked by the staging of the Bury Pageant, when the townspeople presented a spectacular dramatisation of the town's history in the Abbey Gardens. Frederick Pawsey was official publisher and printer of postcards and programmes. In his business he travelled the county in a pony and trap, which appears in some of his postcards with the photographer's car.

Frederick Pawsey was a committee member of the Bury Alexandra football club, a founder member and captain of the town's Risbygate bowls club, and captain of the Northgate bowls club. His sons, Tom, Ernest and Frederick, worked for his company before pursuing military service during the First World War, after which they became travelling representatives for the firm across East Anglia. They also played for Bury United (now Bury Town football club) and the county cricket team.

He died on Christmas Day 1953 and was buried in the town cemetery, but F.G. Pawsey and Co. continued in business in Hatter Street until 1991.

Walton Burrell

Walton Robert Burrell was born in Suffolk in 1863, the son of a farmer. Although deaf, he learnt French, German, Italian and Spanish. He travelled the county, first on a penny-farthing bicycle, then on a tricycle. A scrapbook of his photographs in the West Suffolk Record Office says that he taught himself photography in February

1883. During the First World War he spent much time photographing the activities of Allied troops in the Bury area and helping the military hospital at Ampton Hall. Also a keen stamp collector and lepidopterist, he travelled abroad in pursuit of his interests, and visited Australia to meet Australian soldiers that he had befriended when they were stationed in Suffolk during the war. He died on 23 November 1944 and was buried at Fornham St Martin in a funeral attended by former members of Ampton Hospital.

John Irving Farringdon

Little is known about John Irving Farringdon. He is first recorded as living in Bury St Edmunds in 1911, when the rate books show him as resident in Lower Baxter Street. The following year *Kelly's Suffolk Directory* shows him operating as a photographer from that address. The rate books show that he had left the town by October 1914. (It has not been established if this was because of the First World War.) He published a wide range of Suffolk postcards, known as the *Farringdon Series*, which are of interest as they can be dated to the years immediately before the First World War.

Owen Halliday

Owen Arthur Halliday was born in Ashley, near Newmarket, in 1915. Leaving school in 1929, during the Depression, he found a camera when helping a local tradesman transport ashes to a rubbish dump. After reassembling this he taught himself photography, making an improvised darkroom in the lean-to washhouse of his family home. The shopkeeper at Ashley was sufficiently impressed with the products to contact an Ipswich firm, who cooperated to retake the scenes and publish them for sale in the village. Owen Halliday later became a lecturer at the West Suffolk College in Bury St Edmunds (maintaining his interest in photography). After his death on 21 July 2003 his ashes were scattered on Newmarket Heath.

1

Bury St Edmunds

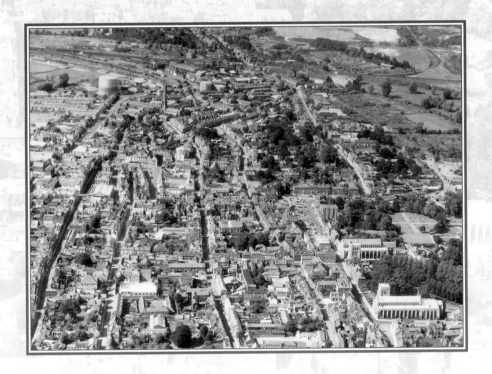

An aerial photograph of Bury St Edmunds in the 1960s. (*St Edmundsbury Borough Council Museum*)

Street Scenes And Public Buildings

Bury St Edmunds, situated centrally in West Suffolk, has always been regarded as the region's capital. The town is named after St Edmund, the last Anglo-Saxon king of East Anglia, killed by Vikings in 869. His body was later moved here, so the pre-existing settlement of Bedereceworth must have been sufficiently important to be an appropriate resting place for a martyred king. The name 'Bury' derives from the Anglo-Saxon word *burgh*, meaning a fortified and defended settlement. The town owes much of its importance to the great abbey that was built to house St Edmund's remains. Established by King Canute in 1020, this became one of the largest and most magnificent monasteries in Europe. Not only did the Abbey bring wealth into the town: it possessed the power to ensure that no other community in the region would grow sufficiently to rival Bury St Edmunds for wealth or importance. When the Domesday Book was made in 1086 Bury St Edmunds was one of the ten wealthiest towns in England.

St Edmund's Abbey was closed in 1539. Most of the abbey buildings were demolished, but even then they were too large and too well built to be completely destroyed, and substantial ruins survive to this day. The town retains much of its heritage as a thriving medieval metropolis: the layout of the town centre still runs in alignment to the abbey precinct, a layout designed by the medieval abbots.

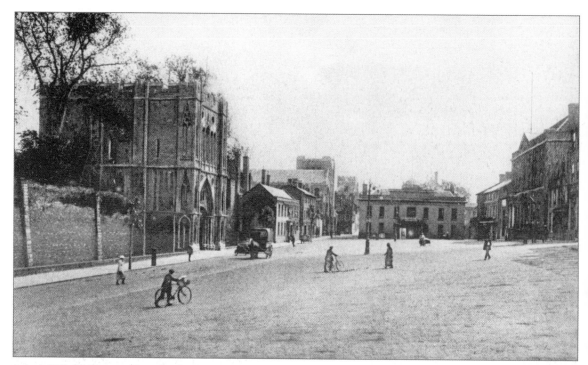

Angel Hill facing south, where Bury Fair was held, *c.* 1900. Started by the Abbey for trade, by the seventeenth century the fair had become an event in the aristocratic social calendar. It later fell into decline and was abolished in 1871. The Abbey Gate (left) was built after 1327 as the entrance to the Abbey precinct. The Athenaeum, at the far end of Angel Hill, dates from the seventeenth century but was remodelled in 1789 for fashionable balls and functions. (*Author's collection*)

In the seventeenth and eighteenth centuries Bury St Edmunds developed into a social centre, as a meeting place for the aristocracy. Although it lost much of its fashionable grandeur in the nineteenth century, it retained all the natural advantages of a central town in a productive agricultural region, on the main communication routes to London and important provincial towns. It continued to be an important market and trade centre. The Suffolk Regiment set up its headquarters here, and when the West Suffolk County Council operated from 1888 until 1974 there was no alternative centre from which to run local government.

Bury St Edmunds has entered the twenty-first century as a vibrant regional centre. Retaining many reminders of its history and its traditional role as a spiritual and regional centre, it is also a centre for local government and light industry. Modern change might be symbolised by the cattle market. Farmers had come here to trade in livestock from time immemorial. Livestock markets were a feature of the town, but these came to an end at the start of the millennium. Whether this was good or bad, its closure was probably inevitable: the market was not making any profit, and was not necessarily relevant to modern agricultural practice. The cattle market site has now been marked for redevelopment. What changes will take place here, as the local economy and identity adapts to the new millennium? It remains to be seen if this development will be in harmony with the town's identity, and will cater for the true needs of a modern Suffolk.

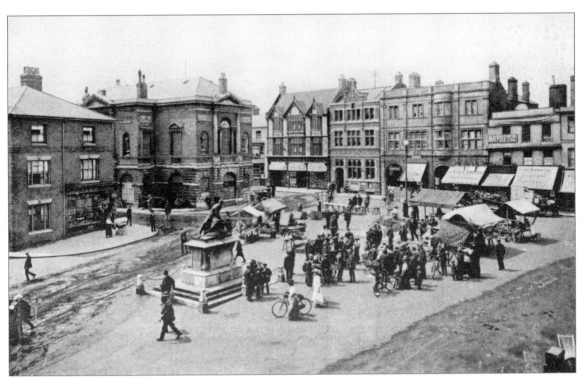

The Cornhill, facing west, on market day, early in the twentieth century. Weekly markets have been held on the Cornhill since the Middle Ages: by the nineteenth century they took place on Wednesdays and Saturdays. Evidently market days attracted fewer stallholders than now, when the Cornhill and the Buttermarket are filled with stalls. (*Author's collection*)

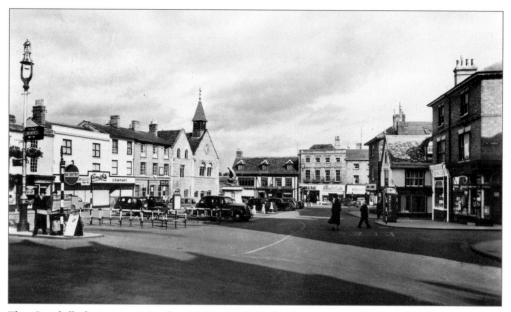

The Cornhill, facing east, in the 1950s. Smith's furniture stores (left) traded from 1866 to 1962. The Castle Inn (next right) stood here from the fifteenth century, but closed in 1985. Moyse's Hall (left of the Castle Inn), a twelfth-century house, became the local museum in 1899. A fall of flints from the west gable in 2002 led to conservation of the frontage (completed in November 2003). The building beyond this (facing west with three dormer windows) was a merchant's house that survived the town fire in 1608. When McDonald's acquired it in 1985 the timber frame and façade were preserved, but cased in concrete to present a particularly faceless specimen of modern architecture. Since then ownership of the premises has been transferred to Burger King. (*Suffolk Jewellery and Antiques*)

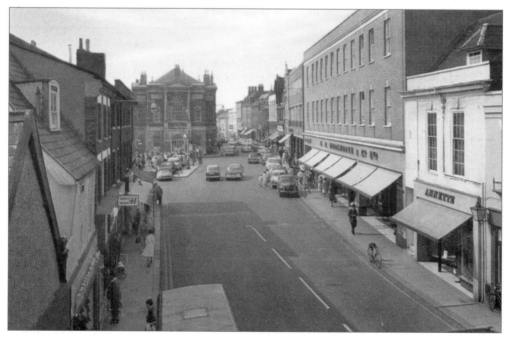

The Cornhill, facing south, in the 1960s, showing incipient motorcar congestion. (*Frank Whitnall*)

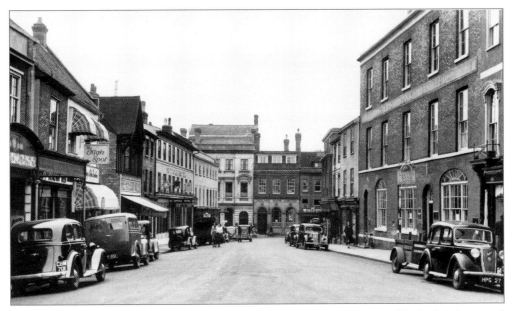

The Buttermarket, facing south, 1950s. The Playhouse cinema is just visible (right). It opened in 1925, and closed on 1 January 1960, although the Playhouse Bar, originally opened to serve cinema-goers, continued trading in a passage from Lower Baxter Street until 1973. (*Author's collection*)

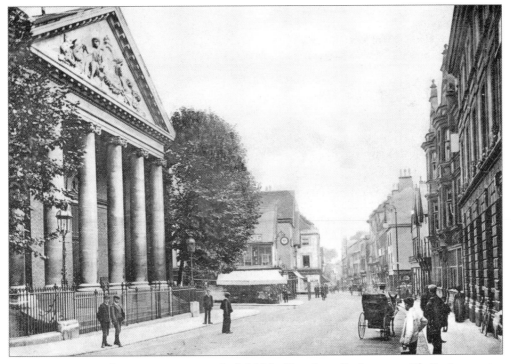

Abbeygate Street, facing east, postmarked 1908. The Corn Exchange, with its impressive classical portico, was built during 1861 and 1862 at a cost of £7,000. A plan in 1959 to replace it with a concrete and glass office block was thwarted. In 1969 shops were installed in the ground floor, and a modern public hall was placed over them. A chrysanthemum show was first held in Bury in November 1854: this is held here every November. (*Author's collection*)

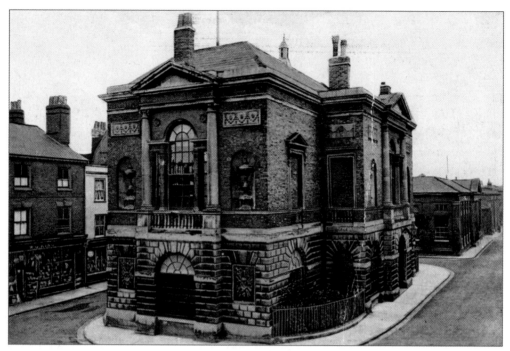

The Market Cross, built in 1774 to designs by Robert Adam. When the ground floor was open to the road, plays were held in the upper room. In 1840 the ground floor was enclosed, and it was renamed the Town Hall. In 1971–2 the upper floor was converted into an art gallery, accommodating temporary exhibitions, at which time it reverted to its original name. This card was postmarked 1909. (*John Cullum*)

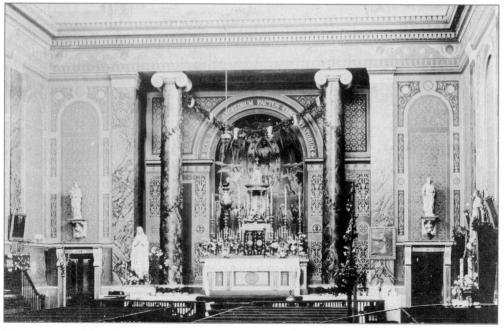

The interior of St Edmund's Roman Catholic church, from a card postmarked 1928. The church was built in 1837 (incorporating an earlier chapel): the interior decoration is now slightly more restrained. (*Author's collection*)

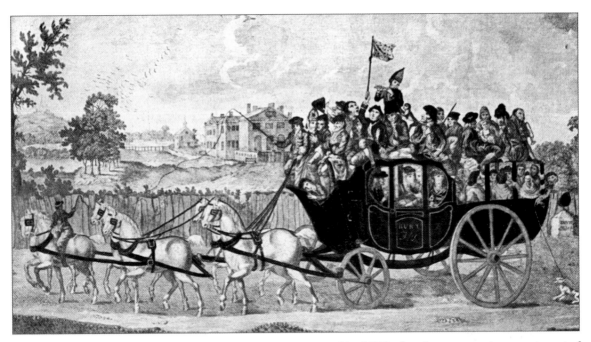

Passengers going to Bury Fair, from a comic engraving printed in 1770, showing an amusing assortment of people in a horse-drawn stagecoach. Moreton Hall, an eighteenth-century Adam-designed country house east of the town, is clearly visible in the background. An interesting view of public transport before the railways, but could six horses really have pulled twenty people (and a monkey)? (*Author's collection*)

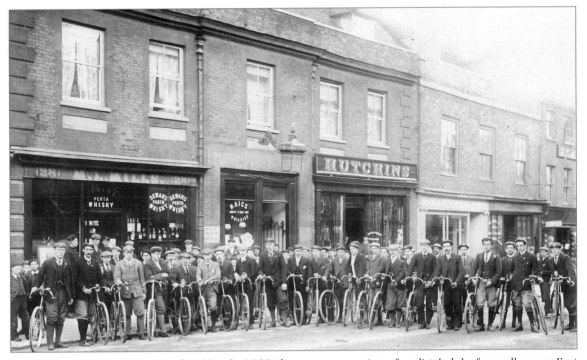

Bury Cycle Club, 1922. On Sunday 23 July 1922 there was a meeting of cyclists' clubs from all across East Anglia in Bury St Edmunds. Members of the town's cycle club were prominent at the event, which was so popular that it would be repeated in July for several years to come. Participants are shown posing on the Buttermarket. (*Darran Green*)

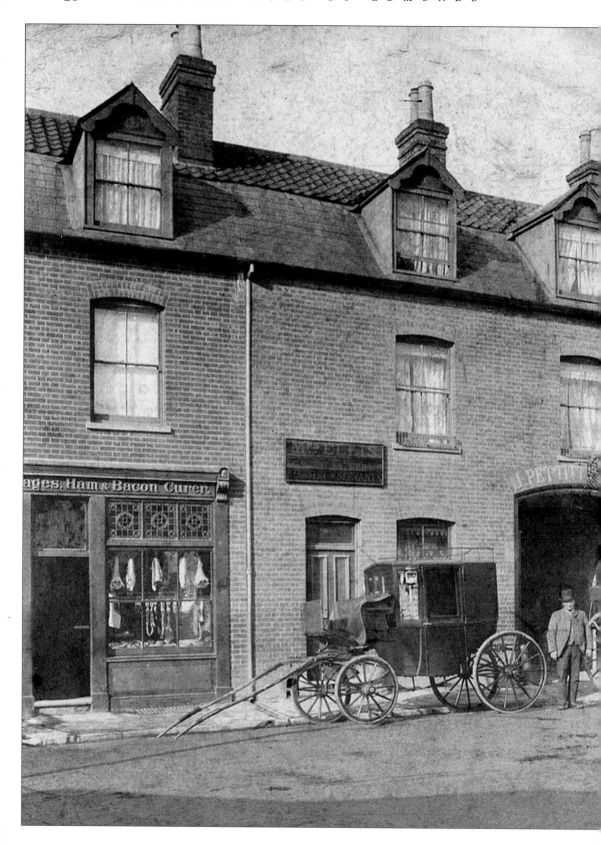

James Pettitt's livery stable. James Pettitt appears in local trade directories from 1892, running a livery stable in St Andrew's Street South (to the north of King Street) hiring and selling horse-drawn vehicles. He was also a corn and straw merchant, and operated a removal service. The pork butcher's shop (left, also run by the Pettitt family) appears in trade directories between 1908 and 1929. By 1912 James Pettitt was also running a garage in St Andrew's Street. (*John Cullum*)

Right: Bareham's Garage in Whiting Street, which occupies premises originally used by a saddler, still operates, as N.W. and P. Rogers. The little boy looking through the railings is a member of the Powell family who lived in the house next door: he is now in his 70s. (*N.W. and P. Rogers*)

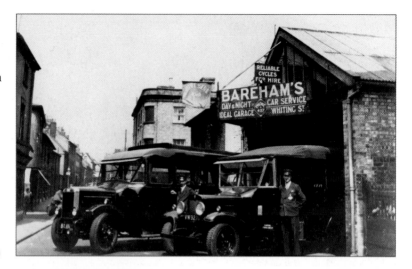

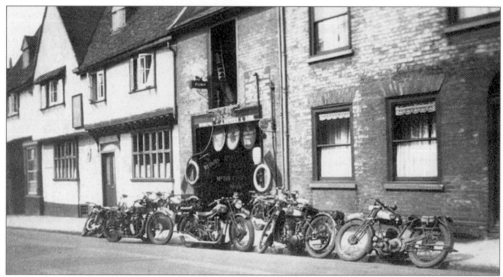

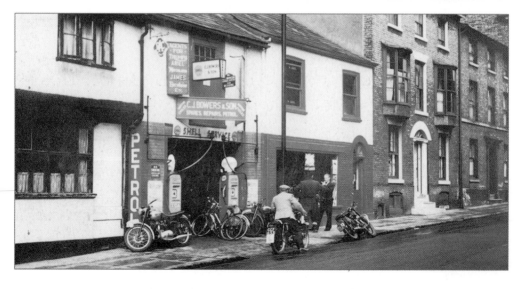

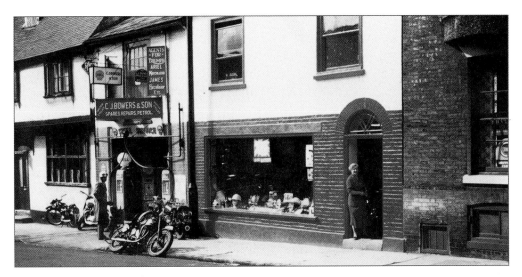

Opposite (centre and bottom) and this page: Charles James Bowers and his son George opened a motorcycle shop in Risbygate Street in 1928. Bowers has continued to trade here, and is now run by George's son, Brian, who started in the business in 1958. As befits a family business, Brian's sons Andrew and Stuart also work here. Now one of the largest and most popular motorcycle shops in East Anglia, in 1998 Bowers expanded into modern premises. In 2003, when the firm was expanding further into a shop specialising in motor cycle clothing, Stuart Bowers visited Italy for creative ideas. (*Bowers Motorcycles*)

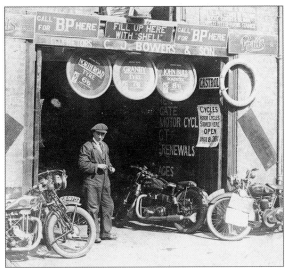

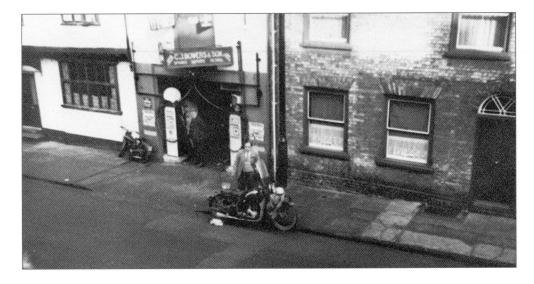

The Cattle Market

The cattle market was one of Bury's livelier attractions. From the Middle Ages livestock was traded on the Cornhill, the Buttermarket or Angel Hill. By the nineteenth century this was causing problems for the townspeople, and in 1828 a new livestock market was started on an open field west of St Andrew's Street. Weekly livestock markets were held on Wednesdays, but these had ceased to be profitable by the 1990s, and the 2001 outbreak of foot-and-mouth disease finally caused its closure. The site is now awaiting development as a shopping centre that will include offices and public amenities. The outcome of this scheme remains to be seen.

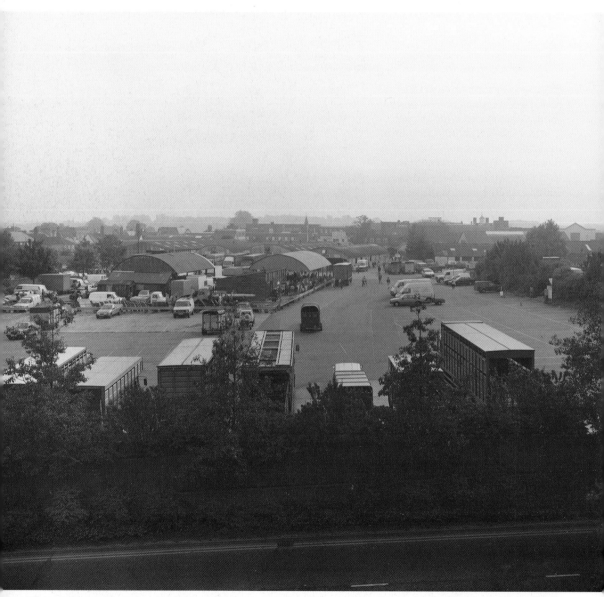

The cattle market in its final years from a nearby multi-storey car park, photographed by Darran Green in June 1994. (*Darran Green*)

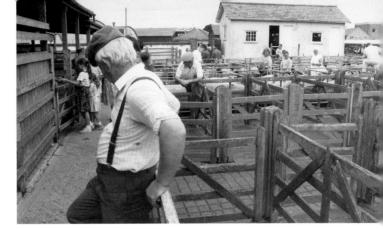

Farmers inspecting animals in the cattle market, photographed by Darran Green, June 1994. (*Darran Green*)

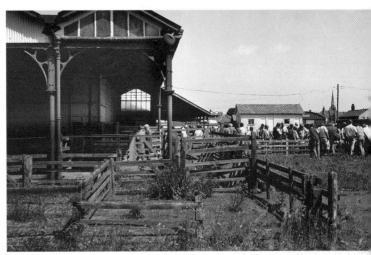

Below: Farmers in Simpson's market. These cast-iron livestock sheds were an unusual survival of Victorian industrial architecture. They were dismantled in 1998, having become unsafe, but the pieces have been kept in storage, and it is hoped to use them in the new cattle market development scheme. (*Darran Green*)

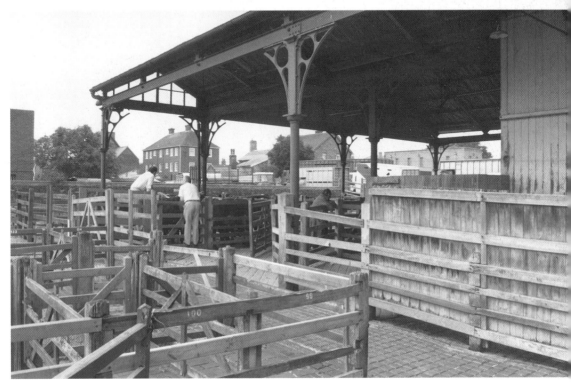

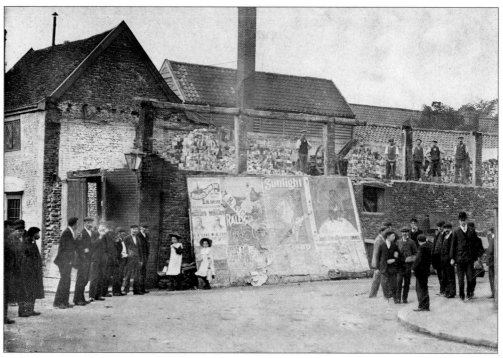

Building works on the south corner of King's Road and St Andrew's Street. A bomb destroyed a warehouse on this spot during a Zeppelin raid in 1915. James Pettitt agreed to build a new structure on the site. This shows workmen clearing away the remains of the old building. Denny Brothers, printers, stationers and art supplies, now stands on the site. (*John Cullum*)

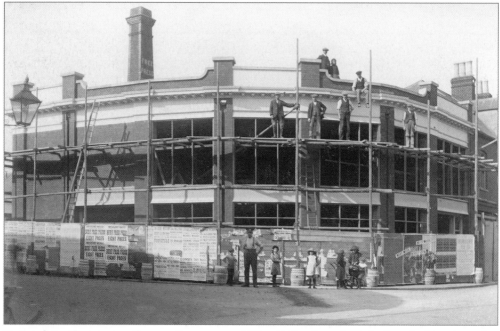

Devonshire House, on the north corner of King's Road and St Andrew's Street, under construction, *c*. 1930. Built as an office block, it is now a nightclub. The chimney of the Bury Free Press works can be seen in the background. (*John Cullum*)

This collection of buildings stood on the corner of Woolhall Street and St Andrew's Street. The metal weighbridge in the road (right) is mentioned in a 1907 sale catalogue of Everard's Hotel as a Pooley's Weighbridge, capable of weighing 4½ tons. (*John Cullum*)

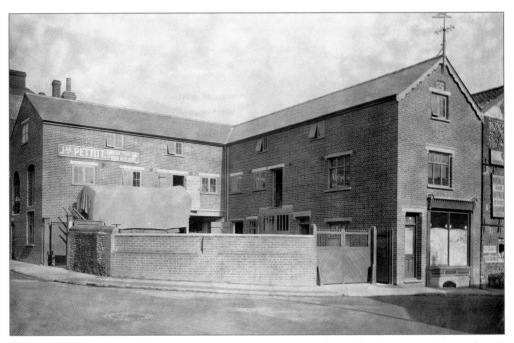

In May 1906 James Pettitt bought the land on the corner of Woolhall Street and St Andrew's Street, and built a grain warehouse on the site. The stone under the right-hand gable (below the racehorse weathervane) bears the inscription 'J. Pettitt 1906'. Part of this wing is used as office buildings. (*John Cullum*)

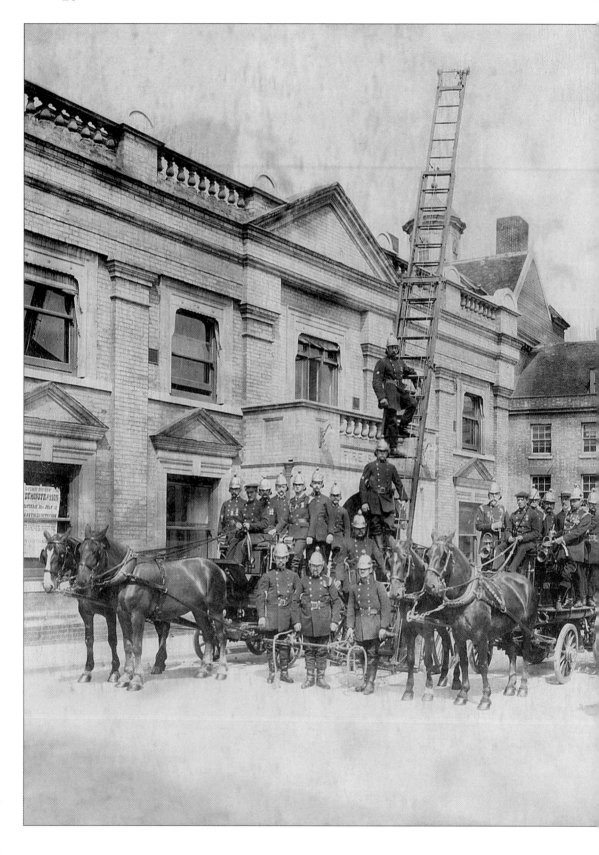

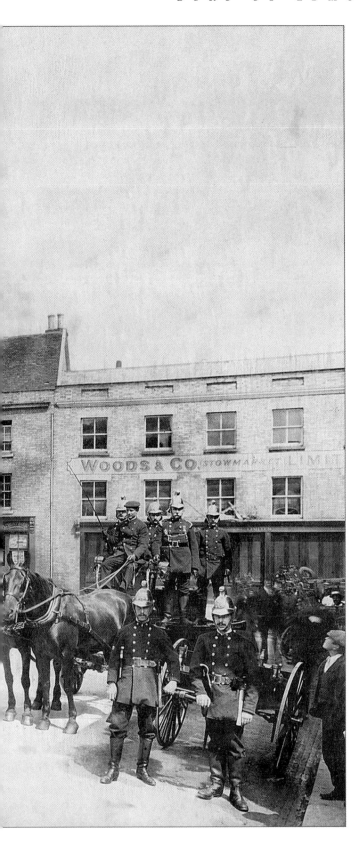

The Borough Fire Brigade (dated by a poster in the left-hand window advertising the forthcoming Lifeboat Day on 21 July 1906). In 1897 the Borough Fire Brigade was moved to the former covered market (between the Cornhill and the Traverse). *White's 1891 County Directory* recorded that the brigade had three engines, twenty-four volunteer firemen and 1,500ft of hose. (*John Cullum*)

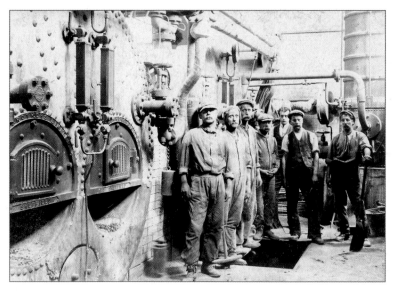

Stokers in the generating station of Bury's power plant. A power plant in Prospect Row (between King Street and the Cattle Market) pumped water and supplied electricity for the town. Some power was supplied by burning rubbish. James William Towler took this photograph of his father, William (Bill), shortly before the First World War (possibly in 1910). Six of these men have been identified. They are: Bill Towler, Tom Holmes, Jimmy Flack, Walter Burrell (engineer), Tom Manning, Walter Froude. (*St Edmundsbury Borough Council Museums*)

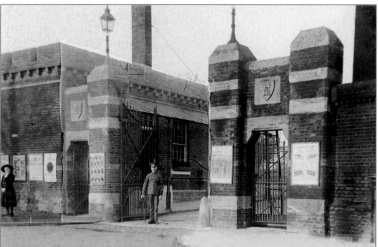

A soldier on guard outside Gibraltar Barracks, the headquarters of the Suffolk Regiment, on the Newmarket Road, just before the First World War. (*Farringdon, Barrie Fordham and Fordham's Garage*)

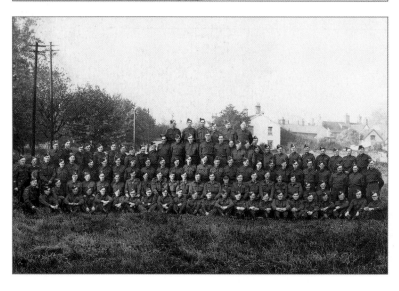

K Company of the Bury Home Guard, 15 October 1944. (*John Cullum*)

The West Front of the Abbey Church: over 200ft long, this conveys something of the magnificence that the Abbey would have presented. After the Dissolution, houses were built in the ruins, creating a pleasingly eccentric and picturesque architectural grouping. The countryside is visible in the background: such rural landscapes remain one of the town's attractions. Since the 1950s the fate of the houses has been uncertain: a proposed conservation scheme has just fallen through. These buildings should be preserved at all costs. (*Suffolk Jewellery and Antiques*)

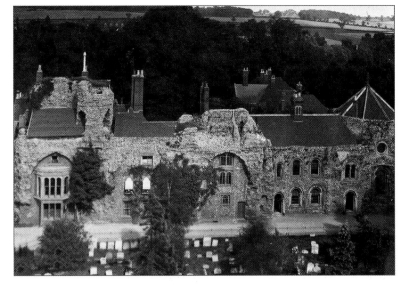

The churchyard in the early twentieth century. A large area of the southern Abbey precinct was used as a cemetery from the eleventh century. This continued in use as the town burial ground until a modern cemetery opened in 1855. Unfortunately, many memorial stones were removed between the 1950s and the 1970s. Despite such destruction, this remains one of Britain's most interesting and attractive burial grounds, and is now conserved as a nature reserve. (*Author's collection*)

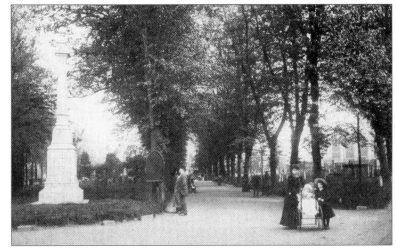

Monastic ruins at the end of Eastgate Street. St Nicholas's Hospital is documented here from the early thirteenth century. After the Reformation a very picturesque house was built on the site, making use of medieval stonework. The empty window came from St Petronilla's Hospital, a medieval house for lepers in Westgate Street that was demolished in the eighteenth century. (*Author's collection*)

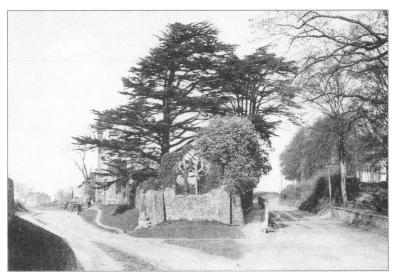

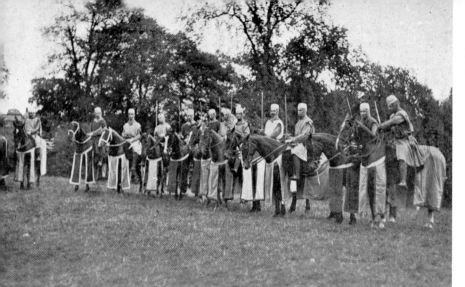

The Reinterpretation of the Past

Left: The Bury Pageant of 1907 was a dramatic presentation of the town's history, scripted and directed by Louis Napoleon Parker, a popular playwright. All the townsfolk assisted, acting, or making scenery and costumes. Staged in July, it attracted an audience from all over Britain, and even abroad. It was a legendary event in local memory: events were recalled as taking place before, in, or after the year of the Pageant. These scenes show the Magna Carta barons assembling in the town in 1214 and the visit of Henry VI and Queen Margaret of Anjou to the abbey in 1447. (*Pawsey*)

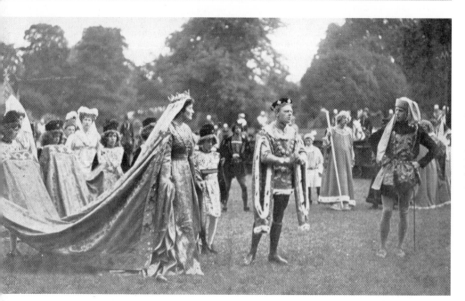

Below: In September 2003 development took place in St Andrew's Street North. A team of archaeologists under the direction of David Gill of the Suffolk Archaeological Unit investigated the site. They uncovered the base of the town defences, which ran along the west side of St Andrew's Street, and the foundations of several early post-medieval timber buildings, as well as a seventeenth-century stoneware 'Bellarmine' bottle, ornamented with the face of a bearded man. (*Author's collection*)

2

The Brecklands

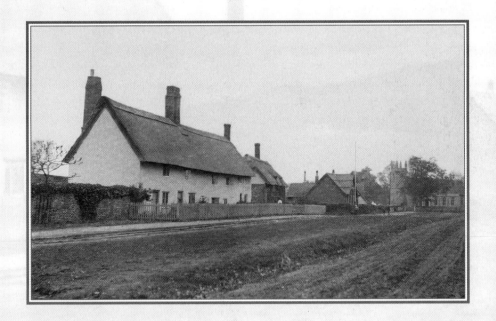

The Street, Fornham All Saints, on a card postmarked 1915. Despite the village's
closeness to Bury, this view has changed little since the picture was taken.
(Joe Wakerley, Bury Bookshop)

The Brecklands, north-west of Bury St Edmunds, whose open heaths attract many naturalists, have a distinct atmosphere and regional identity. They experience the lowest rainfall of any area of Britain, leaving the landscape comparatively dry and parched. Even now it can be seen how this has affected the landscape: villages are relatively small and settlement somewhat sparse, separated by areas of open heathland (or Brecks). It even retains the scars of the Black Death in the fourteenth century; Icklingham and Wordwell never fully recovered from its effects. One railway crossed the Suffolk Brecklands, but there were few people to use it, and it closed even before the Beeching cuts.

The open heaths of the Brecklands provided good 'sporting country'; aristocrats were partly attracted to this area because of the opportunities for hunting, and the area was noted for its country mansions, often situated in large parks, as at Euston, Cavenham or Elveden. In the twentieth century it was realised that the heathland had another use: to train soldiers in battle tactics. During the First World War army units were regularly stationed here for training, and to recuperate from their wounds. The armed forces have used parts of the Brecklands for training ever since.

The Brecklands produced one of Suffolk's representative figures: Robert Bloomfield, the 'Suffolk Poet'. Bloomfield was born in Honington in 1766, and the Honington area has sometimes been called the 'Bloomfield Country'. His poems celebrate Suffolk rural life, which he recalled as a rural idyll (there is much joy and contentment in his verse). Paradoxically, he was too weak for farm work, and when he was 14 he was sent to London to become a shoemaker, so that most of his output was about a remembered landscape and countryside. He later fell out with his Suffolk friends and relatives, who resented his fame (yet often asked him for money), and spent the last years of his life in Bedfordshire. Another literary figure was M.R. James, the son of a Victorian rector of Great Livermere, who became a leading Cambridge academic. M.R. James wrote ghost stories for a hobby; drawing in part on Suffolk folklore and his early memories of the area, they are often described as the best ghost stories in the English language.

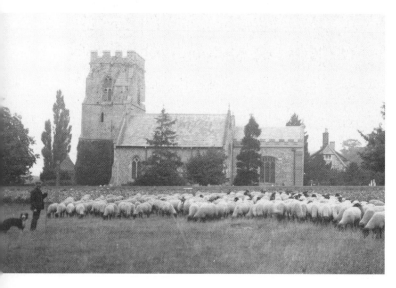

Fornham St Martin: a flock of Suffolk Black-Faced sheep near St Martin's Church. Early in the nineteenth century the Norfolk Horn was crossbred with the Southdown from Sussex to produce the breed shown here, which is now perhaps the commonest sheep in Britain. The shepherd might be a member of the Sayer family: the 1901 census records George Sayer (aged 57) as a shepherd in the village, and his sons, Harvey and Edward (aged 16 and 13) as shepherd's pages. (*Burrell, Joe Wakerley, Bury Bookshop*)

The Street at Fornham St Martin, as shown in *West Suffolk Illustrated* (1907), with the Woolpack Inn to the left, a view which has changed little. (*Pawsey*)

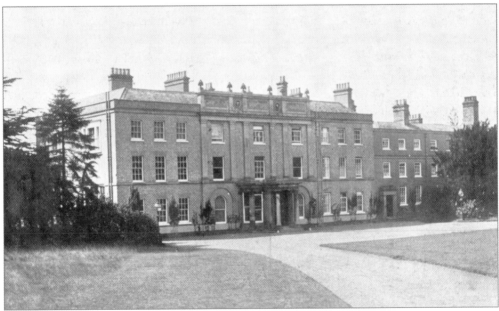

Fornham Hall at Fornham St Genevieve, illustrated here in *West Suffolk Illustrated* (1907), was built in the eighteenth century for the Kent family, wealthy London merchants. After St Genevieve's Church burnt down in 1775 the Kents had the parish re-landscaped as a park. The Hall was demolished in 1951, although the servants' quarters remain. Areas of the Park have been devastated by quarrying or rubbish disposal, although one riverside area is now a nature reserve. At the time of writing the remaining parkland's future is uncertain. Plans to open a golf course have roused controversy and opposition, and it remains to be seen whether this area can be preserved or properly appreciated. However, the remains of Fornham Hall and the church were recently listed. (*Pawsey*)

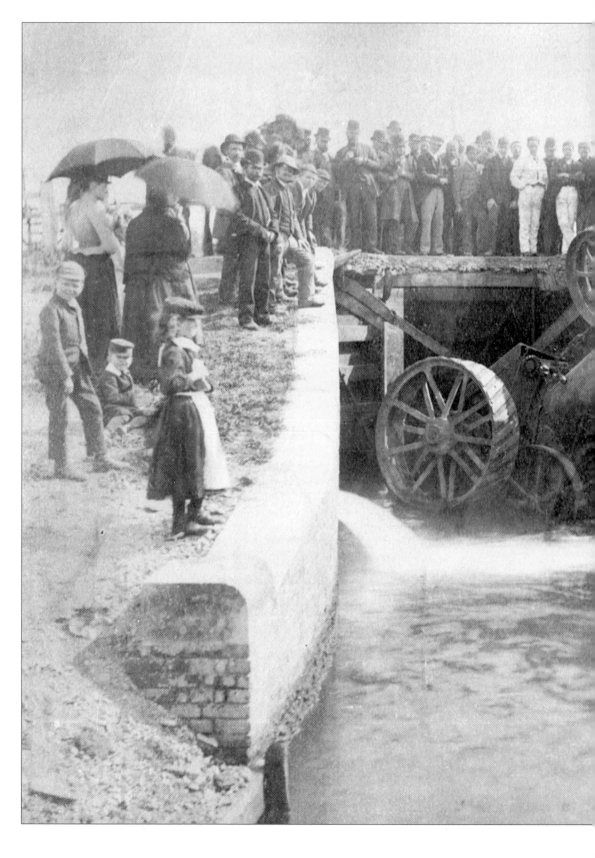

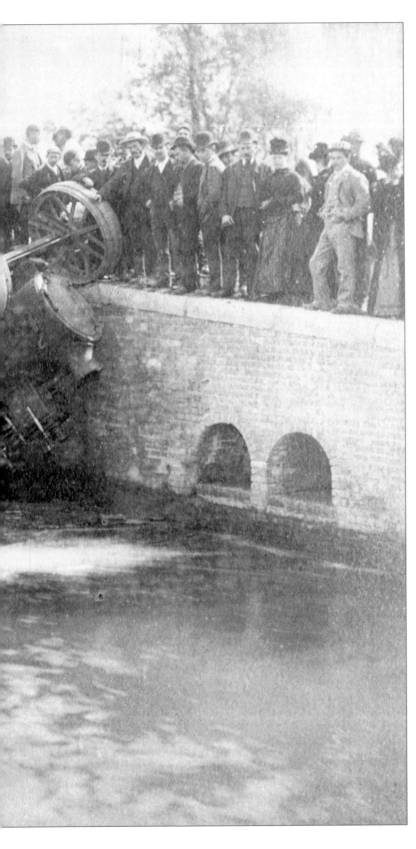

Fornham St Genevieve. On Monday 16 June 1890 Thomas Newell and Abraham Hunt were driving a traction engine from Timworth to Bury. The Tollgate Bridge at Fornham St Martin was being repaired, so they drove over the Sheepwash Bridge between Fornham St Genevieve and Fornham All Saints. The wooden bridge gave way under the engine's weight. Abraham Hunt was able to jump clear, but Thomas Newell was killed.

The Sheepwash Bridge is believed to have been the focal point of the Battle of Fornham in 1173. The Earl of Leicester was involved in a rebellion against Henry II, but his troops were intercepted and routed by royal forces when trying to cross the River Lark. (*Darran Green*)

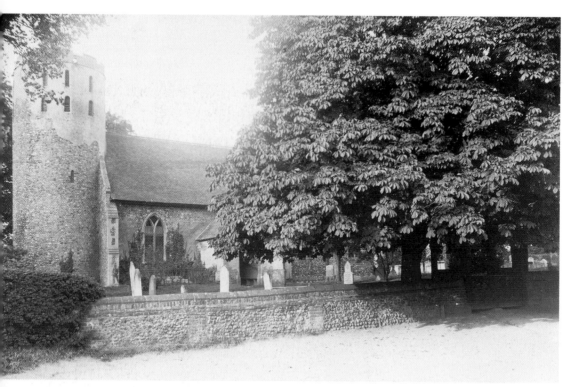

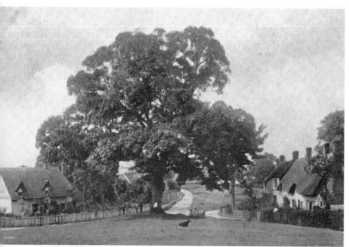

Above: St Giles's Church at Risby was mentioned in the Domesday Book. Here it looks pleasantly rural with trees growing in the churchyard. Round church towers are a particularly notable feature of East Anglia: there are forty-two in Suffolk and 126 in Norfolk, but only thirteen elsewhere in England. It is uncertain precisely why so many were built in this region. Risby's tower dates from shortly after the Norman Conquest, and must be one of the best examples in Suffolk of unaltered Norman (or Romanesque) architecture. (*Joe Wakerley, Bury Bookshop*)

Risby is centred on two village greens. Pawsey's published the view of Lower Green (*middle*) in about 1903, while the view of Upper Green (*lower*) is postmarked 1924. They are still pleasant open spaces, although the well on Upper Green has vanished. (*Middle, Bob Pawsey; lower, Joe Wakerley, Bury Bookshop*)

Hengrave Hall, an important example of Tudor architecture, was built from 1525 for Thomas Kytson, a wealthy London merchant. This photograph was taken just before the First World War, when it was still a private house. It is now run as a Christian retreat. The exceptionally beautiful decoration above the entrance (centre) has recently been carefully conserved. (*Farringdon, Joe Wakerley, Bury Bookshop*)

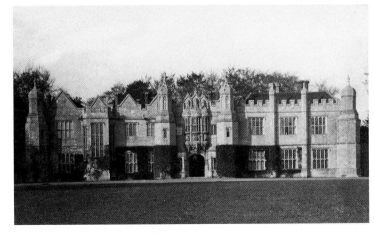

In May 1912 the Loyal Suffolk Hussars camped at Hengrave Park for two weeks. They were territorial yeomanry (volunteers who rode horses): a medieval yeoman was a man of wealth and status, and even in 1912 a yeomanry officer had to be a gentleman who owned a horse. After the Boer War the yeomanry had to adapt to modern warfare, and spent a fortnight training each year. The Suffolk Hussars formed part of the 15th Battalion of the Suffolk Regiment, and served during the First World War. (*Farringdon, Joe Wakerley, Bury Bookshop*)

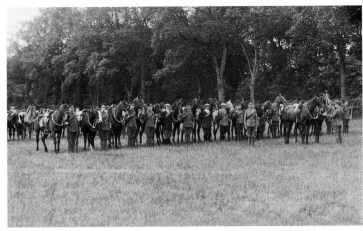

Hengrave Hall was used as a hospital during the First World War. Walton Burrell took this photograph of some staff, patients (and friends) on 22 April 1918. The message on the back says 'With best wishes from sister.' (*Joe Wakerley, Bury Bookshop*)

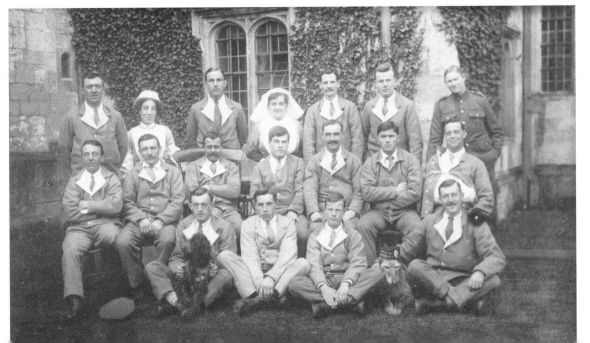

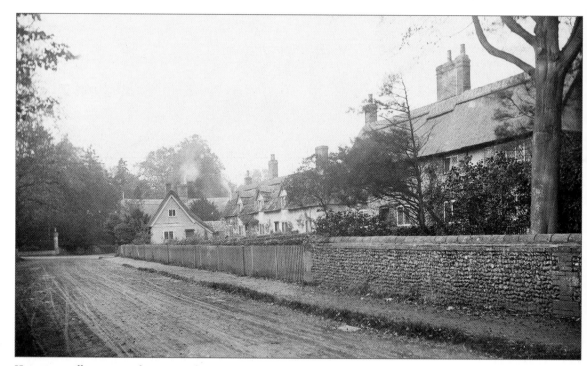

Hengrave village street facing north-west, before the First World War. Many of the houses might have been built at the same time as Hengrave Hall. (*Joe Wakerley, Bury Bookshop*)

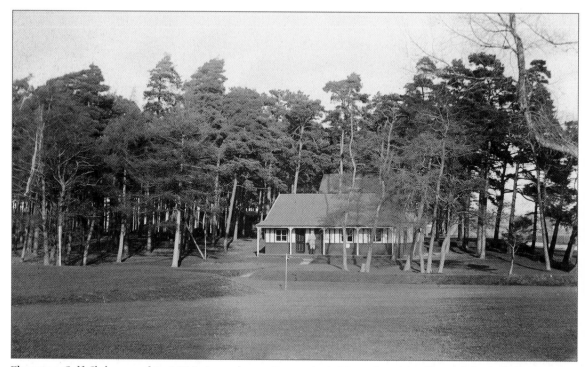

Flempton Golf Club opened in 1895. Legend says it was started by a Scottish officer of the Suffolk Regiment who thought the landscape resembled the sporting countryside of his homeland. The thirty-three founder members included six local clergymen (and four of their wives). The clubhouse was built in 1905. The famous golfer J.H. Taylor designed the course. (*Joe Wakerley, Bury Bookshop*)

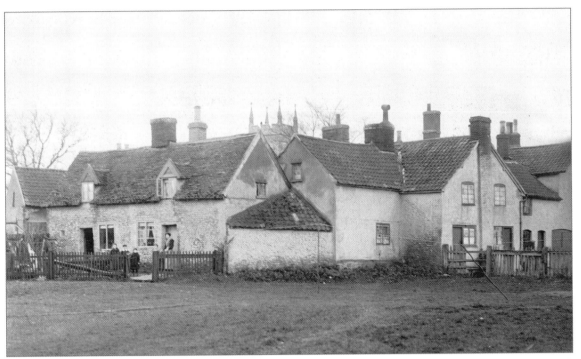

A group of cottages on the south of Flempton village green, surrounding the Greyhound pub. (*Author's collection*)

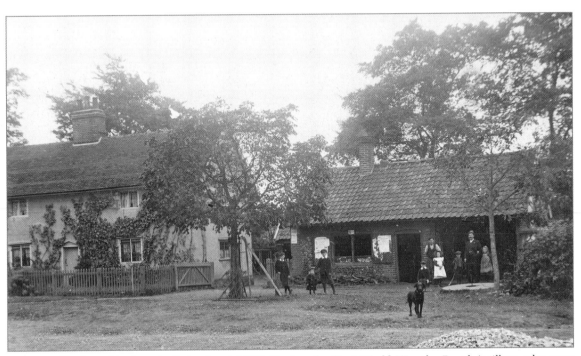

Flempton blacksmith's shop, built in about 1800. During the First World War the Royal Artillery, who were stationed locally, had horses shod here. In the 1920s the Pryke family bought it but it was later rented to the Brooks family. Brian Brooks continued metalworking here until 2003. It still retains a forge, made by Ridley's of Bury St Edmunds. Now a listed building, the present proprietor intends to sell hand-framed knitwear and crafts: a most appropriate use for a building made for a craftsman. (*Joe Wakerley, Bury Bookshop*)

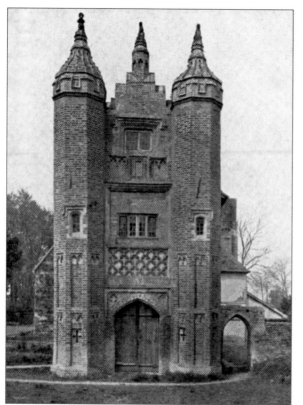

Left: West Stow Hall, probably built by John Crofts, who acquired estates here in 1520. It has recently been suggested that it was a hunting lodge. These were constructed on a small scale in an elaborate manner, for sporting purposes rather than permanent residence. In 1909, when it was in danger of collapse, the Cadogans of Culford Hall (the then owners) commissioned William Weir, a consulting architect with the Society for the Protection of Ancient Buildings, to restore it. This postcard was published in 1910 to show the restoration's success. (*Joe Wakerley, Bury Bookshop*)

Below: Culford Hall. The Cornwallis family acquired Culford Hall, a quadrangular Elizabethan mansion, in 1657. Charles Cornwallis (created a marquis in 1792), a general in India and the American War of Independence, had it refaced with white brick. Edward Benyon, who took over the hall in 1823, added the classical portico. (Made of stucco over an iron frame, this was demolished as unsafe in 1947.) Sixty years later the 5th Earl Cadogan added extensions to the north and west, including an extravagant conservatory (left and right). Since 1934 it has been a leading public school. (*Pawsey*)

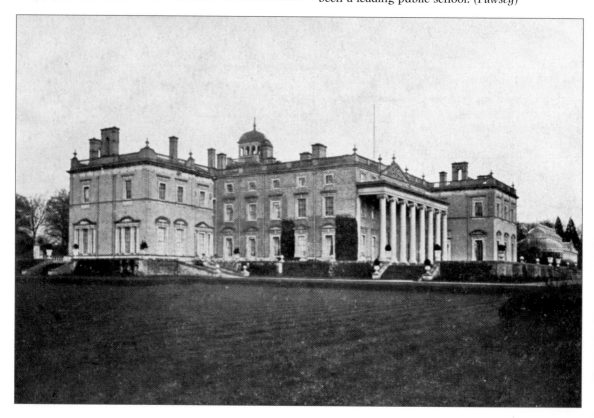

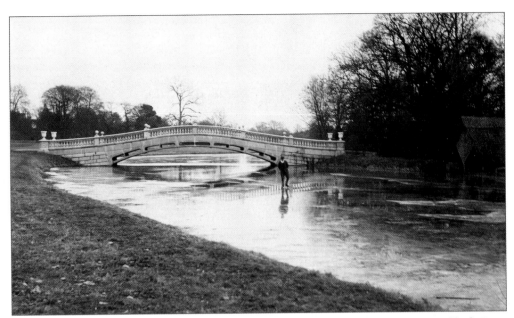

The Marquis Cornwallis commissioned Humphrey Repton to improve his park at Culford. From 1795 a lake was enlarged into an ornamental canal. This iron bridge was built over what was then the main approach to the Hall. Local tradition insists that it was cast from cannons the Marquis captured in India. Cannon would have been expensive to transport and very difficult to re-cast; but if it was made for the Marquis it could be the world's second earliest iron bridge (after the famous structure of 1775 at Ironbridge in Shropshire). (*Joe Wakerley, Bury Bookshop*)

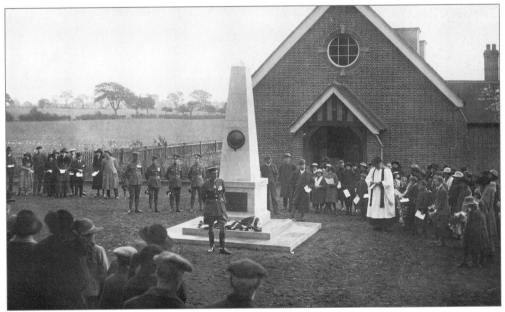

During the First World War twenty-three young men from the Culford Estate (which extended over Ingham, West Stow and Wordwell) lost their lives. A war memorial was erected in front of Culford Village Hall (built just before the outbreak of the war) and unveiled on the anniversary of the war's end. The rector of Ingham is officiating, and the 6th Earl Cadogan (whose brother was among the dead) has just removed the flags covering the memorial. (*Suffolk Jewellery and Antiques*)

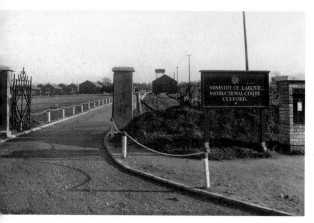

In 1937 the Ministry of Labour opened an Instructional Centre for men from depressed industrial areas on a 6-acre site on the Brandon Road at Culford. When Ernest Brown, the Minister of Labour, visited the camp on 22 September it accommodated 200 men who were learning handicrafts, metalwork and woodwork, and building a recreation hut. (*Joe Wakerley, Bury Bookshop*)

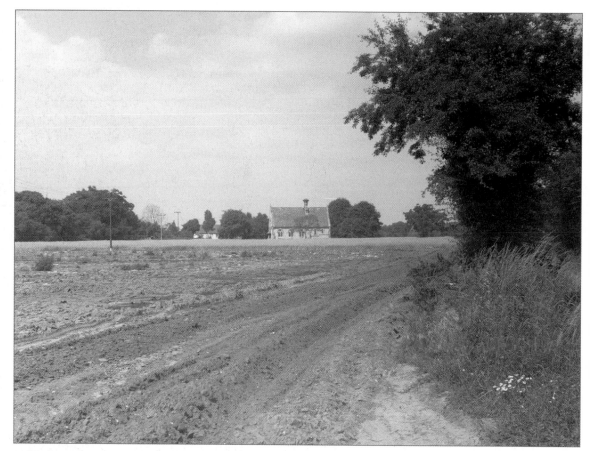

Culford Heath. Known as the 'Forgotten Village', Culford Heath lies at the eastern extremity of the parish of Culford, the only village in Suffolk that is not signposted, and can only be reached by dirt tracks. Two groups of buildings stood here in 1793: by 1841 there were six rows of houses accommodating thirteen families. After the 1940s the population declined, but the buildings remained. This shows a distant view of the depopulated village in 1970. (*Halliday, author's collection*)

In 1840 Edward Benyon of Culford Hall paid for a school to be built at Culford Heath: a small room (foreground), it was probably used more as a Sunday school and preaching hut. In 1875 it became a primary school for the area; a larger classroom and teacher's house (background) were added six years later. In 1929 an inspector reported that it was overcrowded because so many children attended! The school closed in 1945. When this photograph was taken in 1970 Jack Hetcshkum, a Ukrainian expatriate, lived here. Since his death it has fallen into dereliction. (*Halliday, author's collection*)

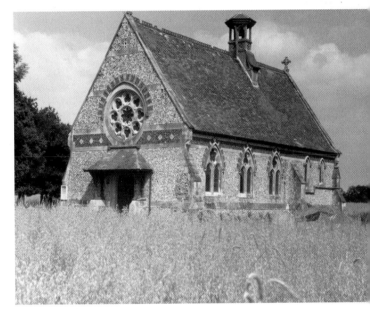

In 1863 Edward Benyon of Culford Hall paid for a chapel to be built at Culford Heath. Designed by Arthur Blomfield, a rising architect of the day, it was dedicated to St Peter and served by curates, who conducted regular services (including forty-eight weddings between 1878 and 1946). The last service took place in 1957. But when this photograph was taken in 1970 the chapel was still structurally sound. It would be good if this could be preserved, as it is now the least altered Victorian church in Suffolk. (*Halliday, author's collection*)

These cottages on the north-east of Culford Heath were built between 1823 and 1840. They fell into dereliction, but when this photograph was taken in 2001 there were plans to restore them. Perhaps some life is returning to this little-known corner of the Suffolk Brecklands. (*Author's collection*)

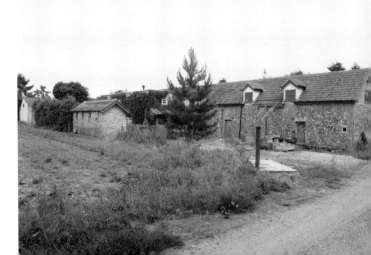

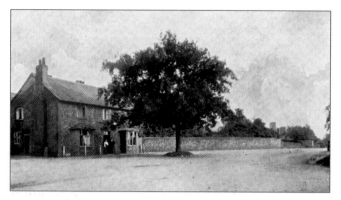

The village pub at Ingham, as shown in *West Suffolk Illustrated* (1907). In 1840 the local landowner, Edward Benyon (who was also a clergyman), closed the pub at Culford. Within three years seventeen beerhouses had opened on the estate, and so Benyon had this pub built to regulate local drinking. Locals still call it by its original name, the Griffin (from the Benyon crest), although its name has since changed twice to the Culford Arms, and then to the Cadogan Arms. (*Pawsey*)

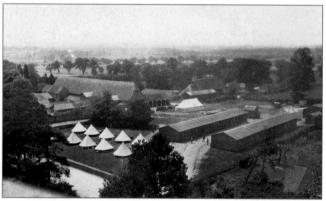

This army camp was built in the First World War. Known as The Camp (or The Huts) it stood south-west of Ingham church. (Place Farm, south of the camp, still operates.) Frank Holloway of the 69th East Anglian Division Cyclists Corp was staying in the left hut when he sent this postcard to his mother in Bedford on New Year's Day 1916. Divisions of the Royal Engineers and the Argyll and Sutherland Highlanders were also stationed here. (*Burrell, Joe Wakerley, Bury Bookshop*)

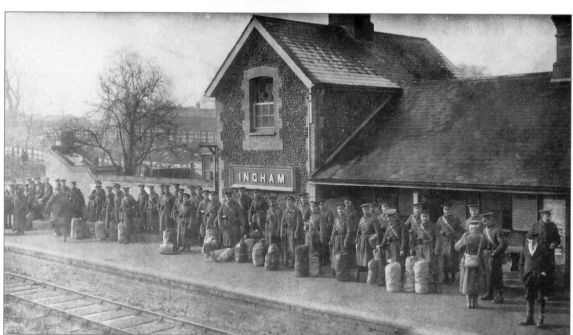

Ingham station stood on the Bury–Thetford line, which opened to passengers and freight in 1876. The service was only permitted to run at 30mph, and was therefore known as the Thetford Flyer. The line supplied Breckland military bases during the First and Second World Wars. This photograph shows Royal Defence soldiers leaving Ingham camp for Masham, Yorkshire, on 11 February 1917. The line finally closed on 27 June 1960, but the station building still stands. (*Burrell, Edward Wortley*)

The small village of Wordwell was depopulated by the Black Death in the fourteenth century and never recovered. Even now there are only a few scattered houses and a small church in the parish. The Hall, the only house of any size, was built in 1550. It was never more than a tenanted farmhouse, but is so named because it stood on the site of the Manor House. (*Joe Wakerley, Bury Bookshop*)

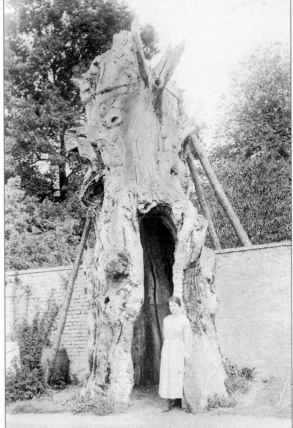

This hollow oak tree stood in the garden, west of Wordwell Hall. In 1921 C.A. Bryant, the tenant of the Hall, reckoned it to be over a thousand years old. It decayed and finally disappeared in the 1960s. (*Joe Wakerley, Bury Bookshop*)

Timworth. The hedge-lined track running left from St Andrew's Church once marked the north side of the village green. From the eighteenth century the lords of the manor encroached on the green, and had the adjoining houses demolished (replacing them with newer houses to the south-west), leaving the church in the middle of the fields. Alec Bull, a stockman at Timworth from 1949 to 1951, relates his experiences in his autobiography, *The Lowing Herd* (1999). (*Joe Wakerley, Bury Bookshop*)

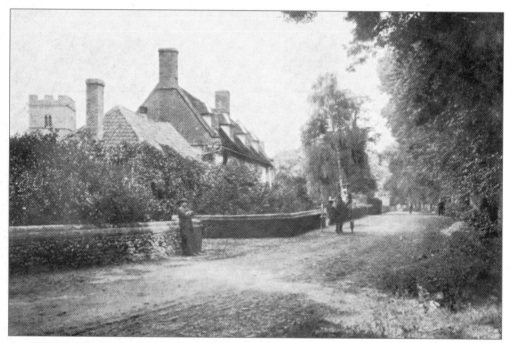

Ampton. The outward appearance of this very attractive hamlet has changed little since this postcard was published in about 1903. The building in the foreground was erected in 1705 as a school for local boys, with funds provided by the Calthorpe family. With compulsory education a schoolroom was added to the south (left). The school closed in 1940, and the schoolroom was demolished in 1957. The school endowment now helps village projects, sometimes assisting villagers with higher education. (*Pawsey*)

Ampton Hall was built for the Calthorpe family, lords of the manor in 1628. Devastated by fire in 1885, it was carefully rebuilt in its original style. Between October 1914 and January 1919 it was a Red Cross Hospital for soldiers serving in the First World War. This postcard was sent on 31 October 1914 by a patient who signed himself D. Dean. (*Burrell, author's collection*)

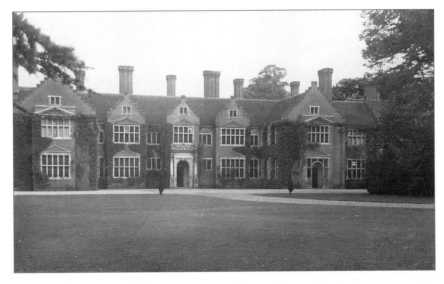

The hospital at Ampton Hall treated 6,568 sick or wounded soldiers. Walton Burrell, who did much to help the staff and patients here, took this photograph of a ward in the Hall grounds. (*Burrell, Joe Wakerley, Bury Bookshop*)

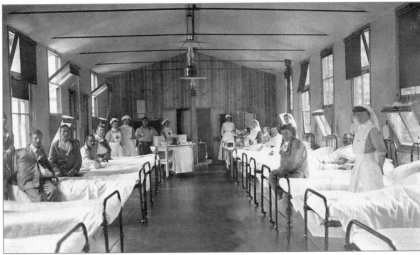

The interior of St Peter's parish church, Ampton. The east window commemorates the rebuilding of the Hall after the 1885 fire: the lower section of the central light shows Shadrach, Meshach and Abednego in the fiery furnace. The photograph predates 1918, as the memorials to the First World War are absent. The candles and gas lamp were normal forms of interior lighting at the time. (*Author's collection*)

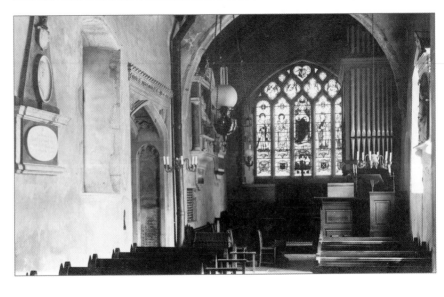

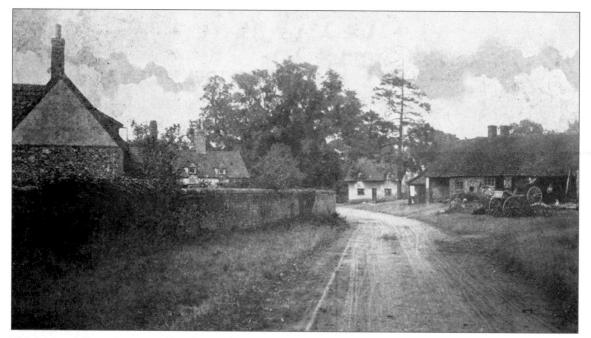

This view of Great Livermere has hardly changed since 1907 when it appeared in *West Suffolk Illustrated*. The blacksmith's shop (right) was derelict and in danger of collapse, but it was recently bought by Brian Harding, a blacksmith, and restored to working order. (*Pawsey*)

The almshouses (left) and village shop (right) stood at the end of Church Road, Great Livermere; the corner of the churchyard wall is just visible to the left. The apple tree still grows. In 1935 Beryl Dyson, aged 7, saw a strange little man standing here who so frightened her that she ran to her parents. When they returned he had disappeared. Many years later the Dyson family found a little pottery figure, identical to the man, on the spot. Beryl Dyson has since written *A Parish With Ghosts* (2001), describing twenty-three sightings of ghosts in Great Livermere, making it a strong candidate for the most haunted village in England! (*Joe Wakerley, Bury Bookshop*)

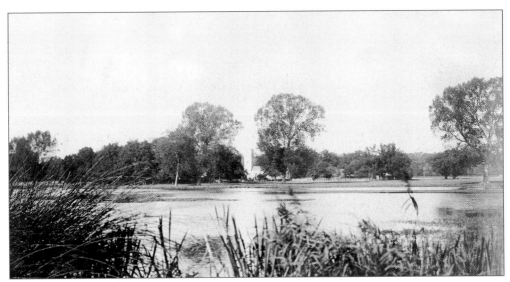

The mere that gave the village of Great Livermere its name, in 1908, photographed by Walton Burrell. Ghost story enthusiasts know the village as the early home of M.R. James. The son of the rector, he became a distinguished Cambridge academic. As a hobby he wrote ghost stories, which aficionados of the genre regard as the best in the English language. M.R. James wrote a suitably ghoulish poem about the mere:

All through the rushes
 and in the bushes,
Odd creatures slip in the dark,
And sulky owls with feathery cowls
Go sweeping about the park

You heard a foot pass,
 it trailed over the grass,
You shivered, it came so near.
And was it the head of a man long dead
That raised itself out of the mere?

(*Joe Wakerley, Bury Bookshop*)

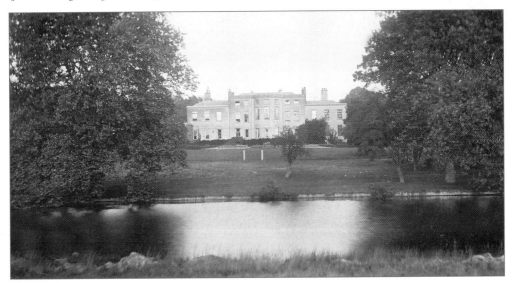

Livermere Hall was built in Charles II's reign. Baptist Lee, who won £30,000 in a lottery soon after inheriting it, enlarged it. The Hall was demolished in 1921: some overgrown foundations stand in a wood. It is the thinly disguised setting for M. R. James's tale of 'The Ash Tree' in his *Ghost Stories of an Antiquary*. (*Joe Wakerley, Bury Bookshop*)

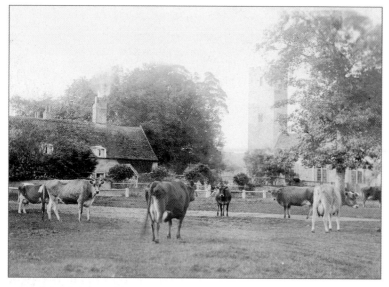

Little Livermere was as large as Great Livermere. But from 1733 Baptist Lee and the Calthorpes of Ampton created a 1,000-acre park here, and most Little Livermere residents were moved to new houses elsewhere. (An extra storey was added to the church tower so it would present a better prospect from Livermere Hall.) By 1911 (the postmark date) only one farmhouse and the church remained of the village. Since the church was not used the roof was removed in 1948: it is now an overgrown ruin, but Anglo-Saxon work has recently been identified there. (*Burrell, Joe Wakerley, Bury Bookshop*)

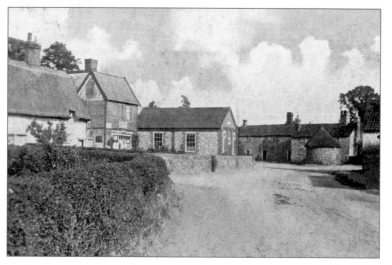

This view of Troston as shown in *West Suffolk Illustrated* (1907) has changed greatly. The intriguing circular building was built in 1808 as a coalhouse for the parish poor. Sadly it has been demolished. (*Pawsey*)

Church Road in Troston. Although many gravestones have been removed from the churchyard, the attractively ramshackle churchyard wall still runs alongside the road, and the pollarded trees still grow beside it. The house opposite is now The Kitchen Garden, a fascinating shop set in an attractive garden, selling plants and rare breed poultry. (*Joe Wakerley, Bury Bookshop*)

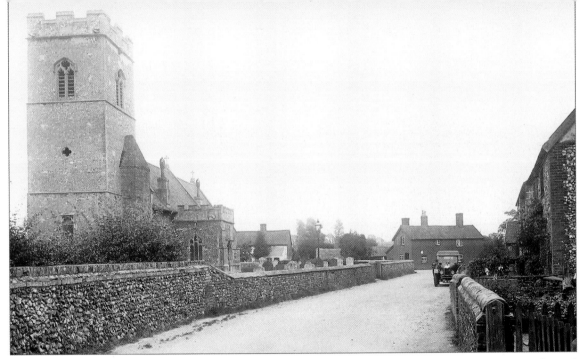

The Street at Honington, facing east. Robert Bloomfield, the Suffolk poet, was born in the house at the end of the road in 1766. When aged 14 he went to London to become a shoemaker. Recollections of Breckland country life inspired him to write 'The Farmer's Boy' and many other poems. Honington parish church, mentioned in the Domesday Book, may have inspired Bloomfield's verse:

> Whilst from the hollows of the tower on high
> The grey cap'd Daws in saucy legions fly.
> Round these lone walls assembling neighbours meet
> And tread departed friends beneath their feet.

(Edward Wortley)

The interior of All Saints' Church, Honington. Although the building has been adapted over the years, it retains a Norman chancel arch, which may have been built at the time of the Domesday survey. To the left and right of the arch are boards showing the Ten Commandments and Creed with Lord's Prayer, presented to the Revd Mr Hind when he retired in 1889. The view pre-dates the 1910 restoration, when the rood loft stairs were opened out and an altar recess was found. The harmonium (left of arch) was replaced by a new organ in 1935. The Revd Mr Illingworth, rector from 1895 to the mid-1930s, made the altar table and reading desk. *(Author's collection)*

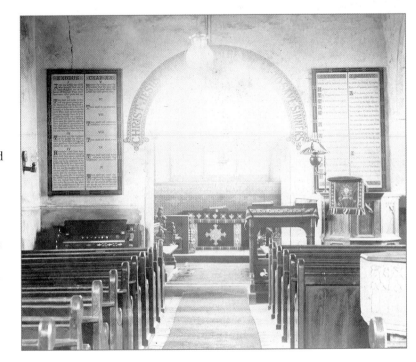

Austin's Farm at Sapiston, now called Triangles House. Robert Bloomfield is said to have worked as a farmer's boy here before moving to London. (*Joe Wakerley, Bury Bookshop*)

The water meadows surrounding the Blackbourne River from the path leading to Sapiston church. When Robert Bloomfield lived in a London garret, remembered landscapes such as this may have inspired him to write these lines about the river valley in his romantic poem, 'The Broken Crutch':

On thy calm joys with what delight
 I dream,
Thou dear green valley of my native
 stream!
Fancy o'er thee still waves
 th'enchanting wand,
And every nook of thine is fairy land.

(*Author's collection*)

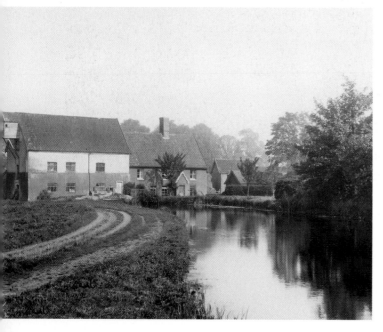

Sapiston water mill. There were two mills at Sapiston in the Domesday Book. This one still stands, although a long way from the village and very difficult to find. Containing floorboards dated 1735, it appears on Kirby's County Map of 1736. The Mudd family, who took it over in 1916, ground corn here until 1967. It is still in working order. (*Edward Wortley*)

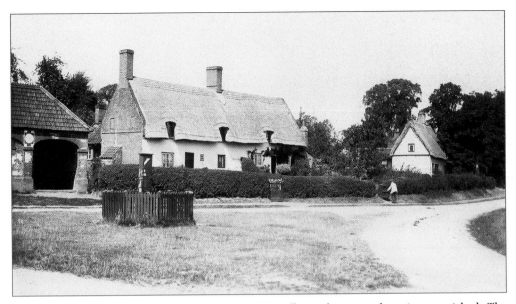

Pump Green, Fakenham, at the south end of the village: the pump has since vanished. The village is the setting for Robert Bloomfield's most enjoyable poem, 'The Fakenham Ghost', about a mysterious presence that follows a woman home. Her house stood on the Green: various traditions say this was either at Bridge Cottage or on the site of the blacksmith's shop. (*Edward Wortley*)

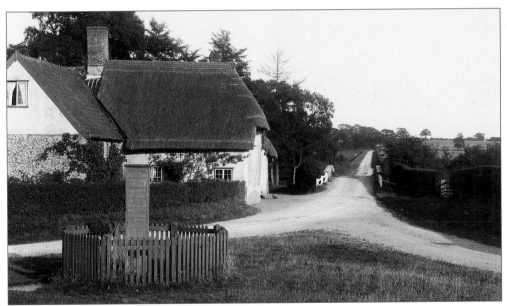

Pump Green looking south to Bridge Cottage. The bridge over the Blackbourne is the scene of a rendezvous between Peggy and Herbert, the lovers in Robert Bloomfield's 'The Broken Crutch':

> They met upon the footbridge one clear morn,
> She in the garb by village lasses worn,
> He, with unbuttoned frock that careless flew,
> And buskin'd to resist the morning dew.

(*Suffolk Jewellery and Antiques*)

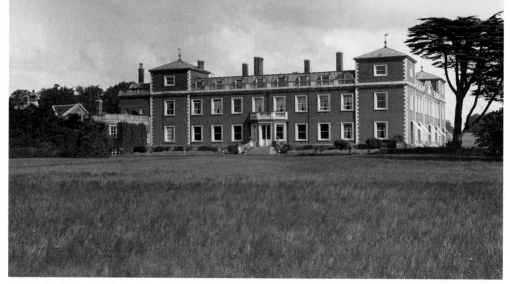

Euston Hall was built for the Earl of Arlington between 1666 and 1670. His daughter married Henry Fitzroy, 1st Duke of Grafton (son of Charles II and Barbara Villiers), and their descendants, the dukes of Grafton, still live here. Two wings of the Hall were burnt down in 1900. They were rebuilt, but demolished in 1950. Robert Bloomfield's best-known poem, 'The Farmer's Boy', published in 1800, describes a year in the life of Giles, a farm boy on the Grafton estate (when the dukes were keen huntsmen). The opening section describes the Hall and its grounds:

> Where noble Grafton spreads his vast domains
> Round Euston's watered vale and sloping plains,
> Where woods and groves in solemn grandeur rise,
> Where the kite brooding, unmolested flies;
> The woodcock and the painted pheasant race,
> And skulking foxes, destined for the chase.

(*Above: Author's collection; below: Edward Wortley*)

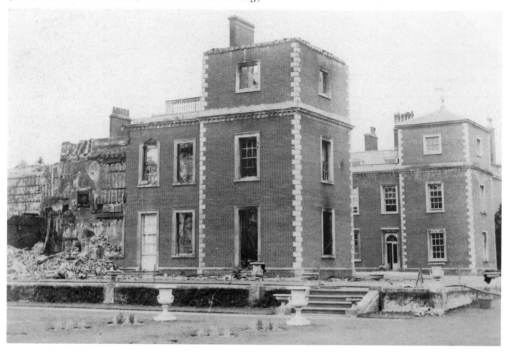

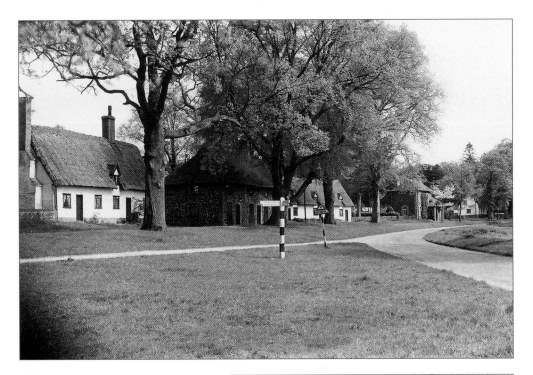

Still bearing the appearance of an estate village, Euston remains very picturesque. (*Edward Wortley*)

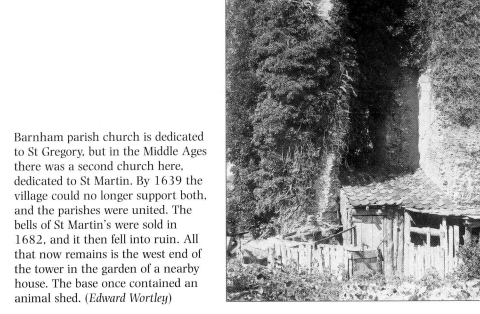

Barnham parish church is dedicated to St Gregory, but in the Middle Ages there was a second church here, dedicated to St Martin. By 1639 the village could no longer support both, and the parishes were united. The bells of St Martin's were sold in 1682, and it then fell into ruin. All that now remains is the west end of the tower in the garden of a nearby house. The base once contained an animal shed. (*Edward Wortley*)

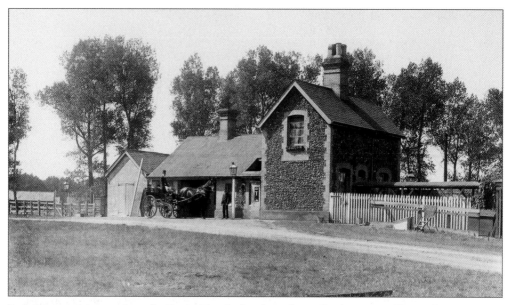

Barnham station stood on the Bury–Thetford railway line. The line was of limited importance, although this station did assume some significance during the Second World War, when special sidings were built to serve a factory nearby for the ICI Corporation. One of Britain's largest bomb dumps was also built here, and 720,000 tons of explosives were transported from here in 132,729 wagon loads between 1939 and 1945, many in secret trains during the night. The line closed in 1960, and the station no longer stands, but traces of the sidings at the ICI factory survive. (*Edward Wortley*)

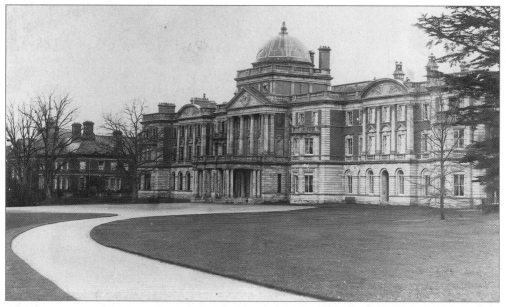

Elveden Hall. Duleep Singh, the last Maharajah of the Punjab, was sent to Britain by the British authorities. In 1863 he bought Elveden Hall, and had it rebuilt as the centre of a sporting estate. Thirty years later Edward Cecil Guinness, 1st Earl of Iveagh, bought it and had it extended to the east and west (left and right) and topped by a central cupola (while developing local agriculture). The interior is ornamented in an elaborate (and authentic) Indian style. Since the Second World War it has lain empty and unoccupied. (*Author's collection*)

The Earl of Iveagh commissioned Clyde Young to design this war memorial to commemorate the forty-eight men from Elveden, Icklingham and Eriswell who died in the First World War. Situated at the meeting point of the three parishes, it was dedicated on 21 November 1921. Standing 113ft high (with a staircase of 148 steps inside) it is the tallest war memorial in Suffolk, and one of the tallest such memorials in the British Isles. (*Author's collection*)

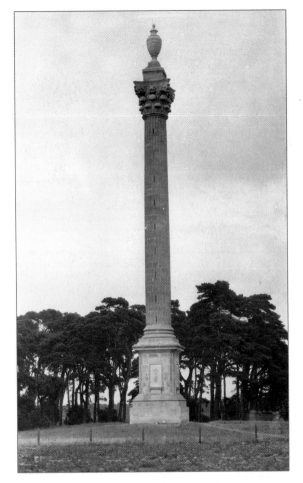

The Earl of Iveagh had this impressive water tower built in the Hall grounds when developing his Elveden estate. Comparable in size with the tower of the Houses of Parliament, the Home Guard used it as a lookout post during the Second World War. (*Author's collection*)

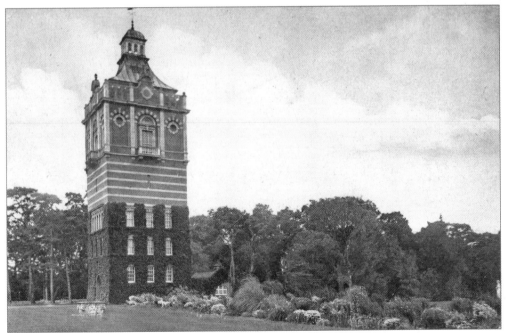

Icklingham High Street as shown in *West Suffolk Illustrated* (1907), showing Frederick Pawsey's cart and his photographer's car. The post office (left) is now a private house. In the early Middle Ages Icklingham may have been a village of some importance (there are two parish churches) but it declined and even now there are wide gaps between the houses: this picture conveys something of the sparse nature of settlement here. (*Pawsey*)

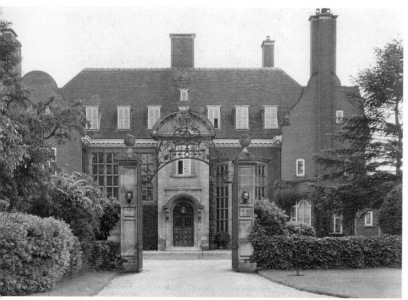

Andrew Prentice designed Cavenham Hall in 1898, with fifty-nine rooms (and seven cellars). Adolphe Goldschmidt bought it four years later. His son, Frank, was a popular local MP. The family anglicised their name to Goldsmith. They sold the Cavenham estate in 1921, and the Hall was demolished in 1949. Frank's son, James Goldsmith, a versatile (and highly eccentric) entrepreneur, developed one of the world's largest food retail companies, which he named the Cavenham Group after the family estate. (*Pawsey, Joe Wakerley, Bury Bookshop*)

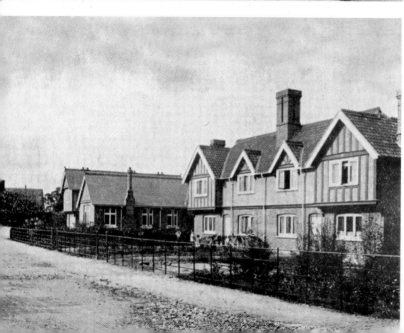

A photograph of Cavenham Street in about 1900, showing houses that Adolphe Goldschmidt had built for his estate workers. The building running at right angles from the road was a village hall, and is now a local social club. The parish was merged with another in 1925, the school closed in 1929 and the village store followed in the 1950s, but it retains a community spirit, and the villagers have set up an outstanding website dedicated to local history and archaeology. (*Pawsey*)

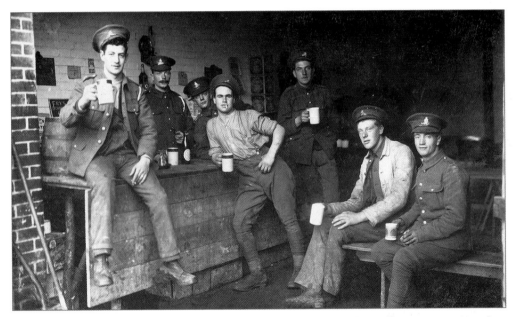

The heavy battery of the East Anglian (Essex) Royal Garrison Artillery was stationed at Cavenham from 1914 until February 1916. This photograph shows soldiers in a canteen in December 1915. From the left: Forrest (sitting on table holding cup), Bombardier Brooking (with moustache, behind table), Lepone (behind table), Clifford (leaning on table), Warde (standing by table) and, seated at right, Harding (light open jacket) and Erridge (dark buttoned-up jacket). (*Burrell, Suffolk Jewellery and Antiques*)

St Ethelbert's Church, Herringswell, was mentioned in the Domesday Book. It caught fire during a Sunday service on 25 February 1869. Sir William Gilstrap, the Lord of the Manor, rebuilt it at a cost of £1,150. It is worth visiting for its modern stained glass, which is probably the finest in Suffolk. (*Author's collection*)

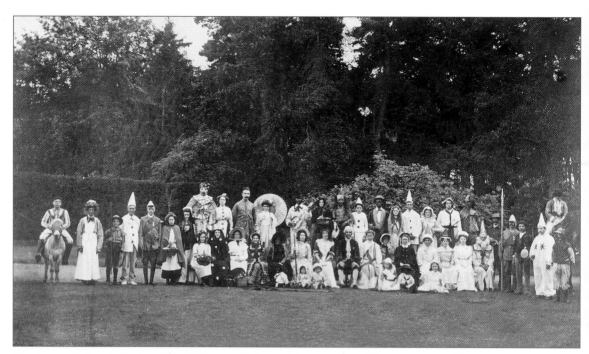

Herringswell Carnival, staged on 22 June 1911 to celebrate George V's coronation. The *Bury Post* reports, 'A very elaborate and instructive pageant of empire was performed by a number of ladies and gentlemen, in company with the schoolchildren. The assembling of the groups and the bright costumes were effectively arranged, and presented a very pretty scene.' At the end of the day there was 'a great tea' and a fancy dress carnival on the Rectory lawn. (*Author's collection*)

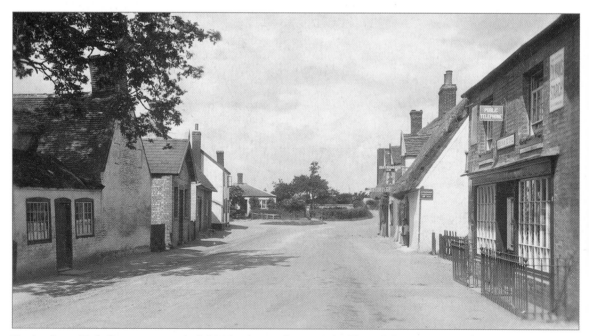

Freckenham High Street, postmarked 1931. The single-storey building (left) pointing away from the road was built in 1894 as a Reading Room, paid for by public subscription. By 1908 it had become the Village Hall. After a new Village Hall was built in 1997 it became a private residence. The post office (right) is now a private house, but the metal support of the public telephone sign is still attached to the wall. (*Author's collection*)

3

The North-East

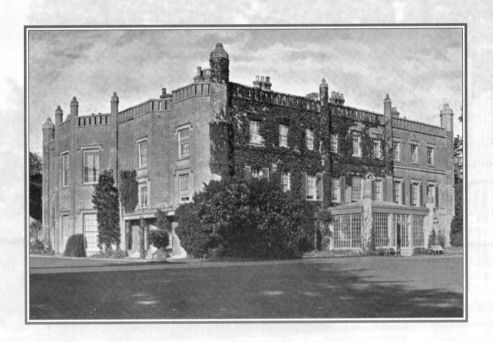

The Bunbury family acquired Great Barton Hall in 1746. Thomas Charles Bunbury
was a horseracing enthusiast: in 1780 he tossed a coin with the Earl of Derby to
decide who should give their name to a new horse race. He lost, so the race was
named the Derby, but Thomas's horse Diomed won the first race. After 1821
Lieutenant General Sir Henry Bunbury had the Hall rebuilt, giving it the appearance
shown in *West Suffolk Illustrated* (1907). (*Pawsey*)

The area north-east of Bury St Edmunds occupies the northern part of the Suffolk region known as The Fielding, partly because of the large open fields that were cultivated here in the Middle Ages, and also from its soils, which were lighter than the boulder clays of Central Suffolk. There was a heavy density of Roman settlement here: there are perhaps more archaeological remains of Roman activity here than in any comparable region of Suffolk. Later on, the main road from Bury to Norwich crossed this area. This became an area of some wealth, noted for its preponderance of yeomen (a wealthier class of independent farmers). There were fewer country mansions here than in some areas of Suffolk. Redgrave Hall, one of the exceptions, was the ancestral home of the Bacons, Tudor yeomen farmers made good, who accumulated sufficient wealth to project themselves into the national aristocracy. Villages with access to the main road achieved some prosperity. In the Middle Ages some communities, such as Ixworth, Botesdale and Walsham le Willows, maintained markets. These had dwindled away by the nineteenth century, but they left their mark on village layouts. Prosperity from Tudor and Stuart times is also demonstrated by the high number of surviving buildings from that era. Bypassed by the railways, the core of the area was particularly affected by later agricultural depressions. Many of the fine houses in Ixworth and Walsham le Willows had been subdivided into tenements by the end of the nineteenth century. Housing conditions had so deteriorated that this was the first part of Suffolk where council houses were built. As car travel developed and historic houses became fashionable residences again the area saw a renewal in prosperity.

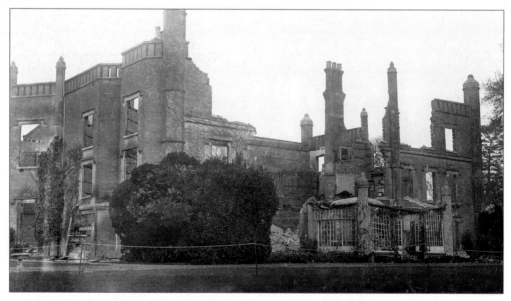

A beam in Great Barton Hall caught fire at midnight on Saturday 9 January 1914. Soon the building had become 'one great hissing, devouring furnace' (*Bury Post*). When the Fire Brigade arrived there was no nearby source of water to extinguish the fire. No lives were lost, and most of the contents were saved, but the building was beyond repair, and the estate was sold off in the following year. In the 1960s a housing estate was built on the site. Some roads are named after the Bunburys' famous racehorses, including Diomed Drive. (*Burrell, Joe Wakerley, Bury Bookshop*)

The region has also drawn from the main road from Bury to Ipswich, which left an impression on the southern part of this region. In 1846 the Bury–Ipswich railway crossed the area. Elmswell, one of the villages to acquire a railway station, even became a small centre for agricultural industries. One of the region's first food factories was built here, and West Suffolk County Council selected it for modern housing development. Other villages, such as Badwell Ash, Stowlangtoft and Pakenham, have retained their historic centres, but modern housing development has taken place on their peripheries. Yet many historic buildings have survived, and several villages, such as Ixworth, Pakenham, Bardwell and Walsham le Willows, actively work to preserve and cultivate their heritage.

The Street at Great Barton, the main road (now part of the A143) running through Great Barton, in about 1900. This road and many adjoining houses were constructed between 1821 and 1828 to bypass the park that surrounded Sir Henry Bunbury's newly rebuilt mansion. (*Pawsey*)

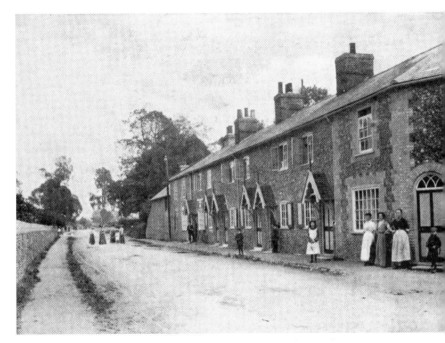

Great Barton extends over a wider area than might be apparent to motorists driving along the A143. Conyers Green, an area of Great Barton to the north-west of the main street, is still a pleasantly rural area, containing many traditional cottages. (*Joe Wakerley, Bury Bookshop*)

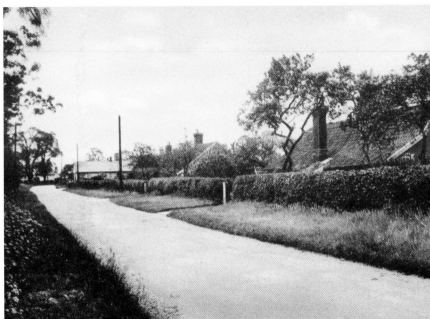

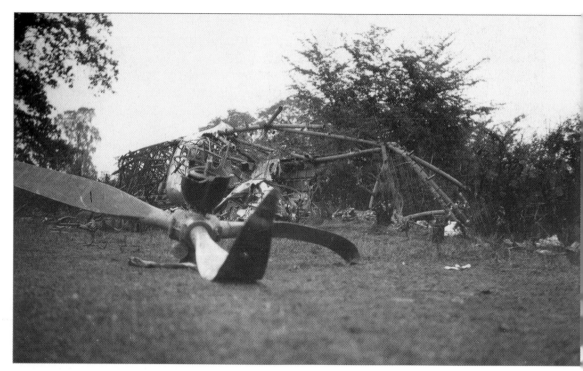

On the night of Saturday 7 August 1938 the RAF was engaged on a practice home defence exercise above Mildenhall. At 12.45 next morning a Harrow bomber was returning to RAF Feltwell when it crashed into some trees on Vicarage Farm in the Conyers Green area of Great Barton. Hitting the ground, the plane disintegrated and burst into flames. The five crew members, aged between 23 and 27, were buried with full military honours at Feltwell. (*Suffolk Jewellery and Antiques*)

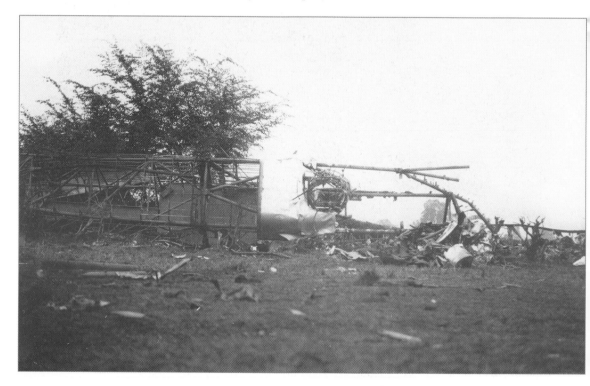

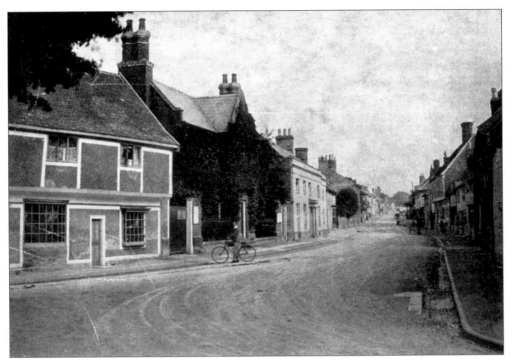

Ixworth. The south end of the High Street, at the start of the twentieth century. The pargetted house (left) is just one example of the village's wide range of historic buildings, many of which have survived in an excellent state of preservation. The ivy-covered building beside it was a police station and magistrates' court. (*Pawsey*)

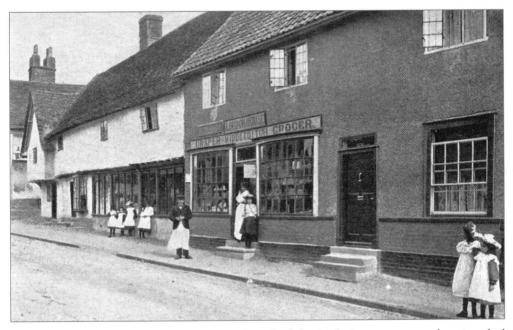

Ixworth. Timber-framed houses at the north end of the High Street, on a card postmarked 1910. The white building to the left is believed to date from 1500: it is now a restaurant. Most timber-framed houses would originally have been covered by plaster like these: the idea of exposing the timber beams is comparatively modern. (*Joe Wakerley, Bury Bookshop*)

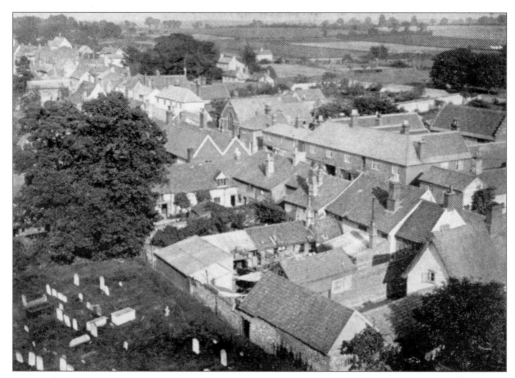

A view of Ixworth, published in *West Suffolk Illustrated* (1907). Taken from the church tower, it was an experiment in aerial photography. (*Pawsey*)

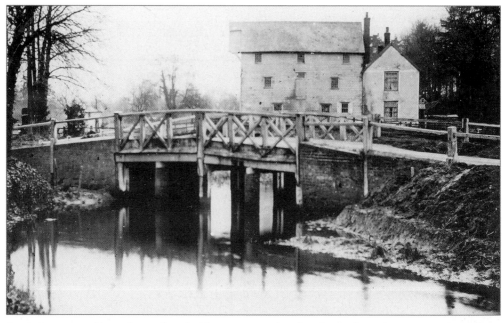

Ixworth water mill stands on the Blackbourne River by the Thetford Road. It was built in about 1800, but incorporates parts of older buildings. In 1545 Hugh Baker left 40s in his will 'to making one bridge of lime and stone at the mill at Ixworth'. Retaining much of the original machinery, it is now a Grade II* listed building. Regrettably, trees have recently been planted between the mill and the main road, obscuring the view in summer. (*Joe Wakerley, Bury Bookshop*)

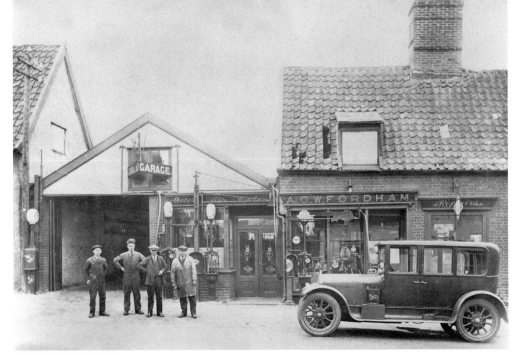

Fordham's Garage, Ixworth, 1925. This opened as a bicycle shop on the east side of Ixworth High Street at the start of the twentieth century. After 1918 it began to sell petrol and repair cars. Albert (Bertie) Fordham bought the shop from a Mr Buckingham in 1920. The car is a Humber 14/40; in the window behind it can be seen items (and advertisements) for Raleigh bicycles. Barrie Fordham continues to operate a thriving garage from modern premises at the top of Ixworth High Street. Left to right: -?-, 'Bunker' Horsenail, Bertie Fordham, Joe Mayes. (*Barrie Fordham and Fordham's Garage*)

Jack Mulley started Mulley's coaches, a leading local transport company, based at Ixworth, in 1938. Jack's grandfather, Charles Mulley, was a baker in the village. He sits on the cart to the left. The photograph was taken at the junction of Stowmarket Road and the High Street in 1898. The building behind the tradesmen has since been demolished, but Ridge Tile House (left) still stands. Notice the little figure on the ridge tiles. This strange ornament was mentioned by M.R. James in his 1930 guide to Suffolk and Norfolk. (*Barrie Fordham and Fordham's Garage*)

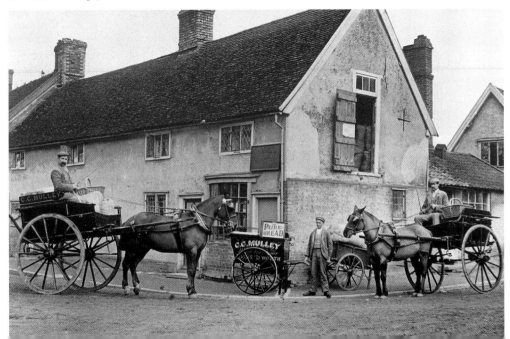

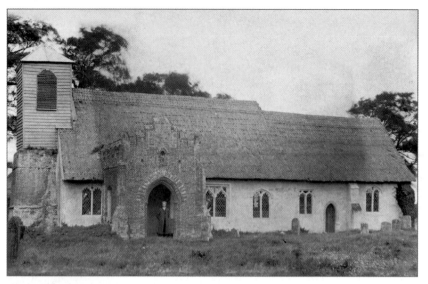

Ixworth Thorpe church stands in isolation on a ridge in the middle of the parish, and is worth visiting for some beautiful medieval bench ends. Field walking shows that an eleventh-century village stood nearby. In the twelfth century settlement moved to Thorpe Green and Easter Green at the Honington and Ixworth ends of the parish. (*Pawsey, author's collection*)

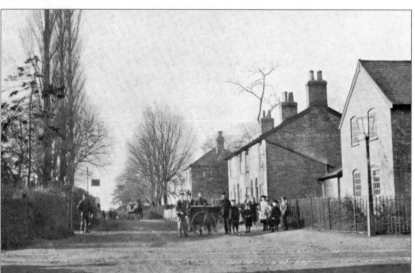

School Street, Elmswell, as shown in *West Suffolk Illustrated* (1907). The nineteenth-century houses and even the garden railings to the right survive. The narrow gauge railway line, which is just visible in the foreground, ran from Elmswell station to the brickworks at Woolpit, a mile away. (*Pawsey*)

The railway crossing gates at Elmswell, probably photographed between 1903 and 1906. Although most of the railway buildings have been demolished, the station still operates as an unmanned halt. (*Pawsey*)

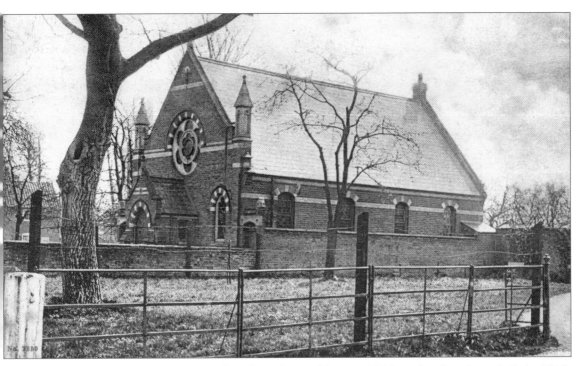

Elmswell Methodist Chapel. A Methodist chapel was licensed here in 1799, and a chapel was built in 1818. This was demolished and another chapel built on its foundations in 1898. The chapel was extended to the north with a new hall and other buildings in 1956. (*Author's collection*)

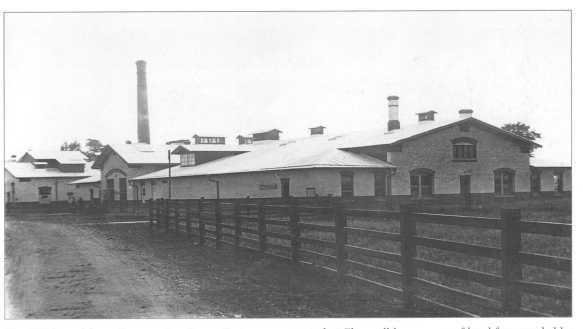

The St Edmundsbury Co-operative Bacon Factory was started at Elmswell by a group of local farmers, led by T.E. Robinson of Woolpit. The foundation stone was laid on 30 June 1911, and the building was opened by Frank Goldschmidt, a local MP, on 25 March 1912. The first samples of meat were sent to George V. For many years the only independent, farmer-owned pig factory in Britain, it was taken over by larger enterprises in the 1970s. (*Farringdon, Joe Wakerley, Bury Bookshop*)

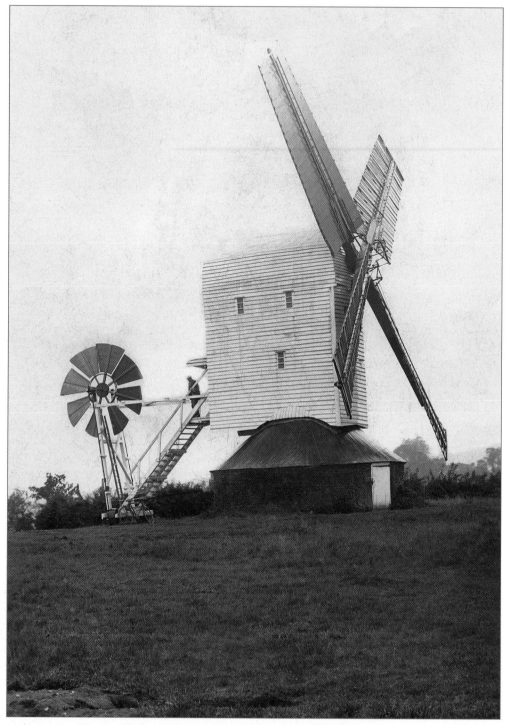

Thurston windmill, on a card postmarked 1915. This mill may have been moved from Pakenham to Mill Lane in Thurston in 1750. In 1900 Mr Cattle bought it for £710, and rented it to R. Carter until 1929. By then it was unlikely that a windmill would have been greatly profitable, and Mr Carter also worked for the railway and ran a haulage company with his brother. After this it passed out of use, and was dismantled in 1950, when some parts were used to restore Pakenham windmill. (*Joe Wakerley, Bury Bookshop*)

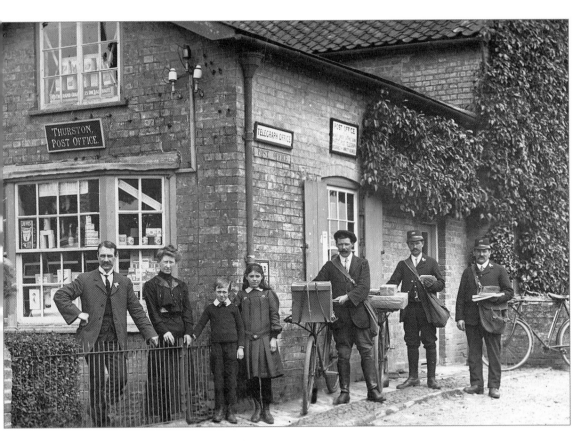

Thurston post office, a postcard from the same local series as the windmill. This became a telegraph office in 1900, and a mail order and savings bank in 1903. Trade directories show that Cyril Charles Bradley was postmaster between 1900 and 1912. (*Joe Wakerley, Bury Bookshop*)

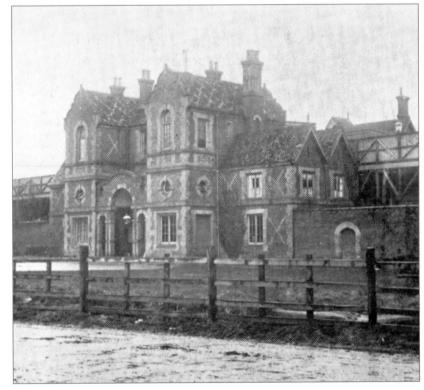

Thurston station stands on a high embankment in the centre of the parish. Frederick Barnes, an architect with the Great Eastern Railway, designed it in a Jacobean style in 1846. It was reduced to an unmanned halt in 1967, but some of the railway buildings still stand. (*Pawsey*)

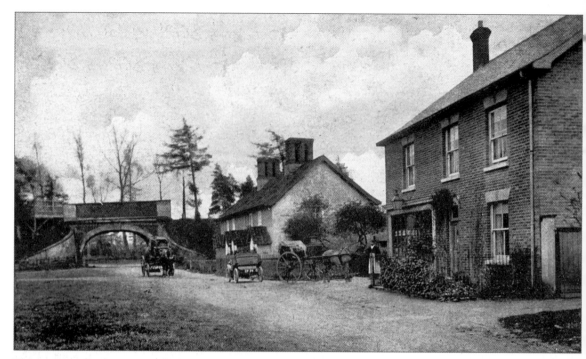

This railway bridge, west of Thurston station, was built to the same design as that near Bury station. Frederick Pawsey's horse and cart and the photographer's car (registration CF 74) appear in the view. (*Pawsey*)

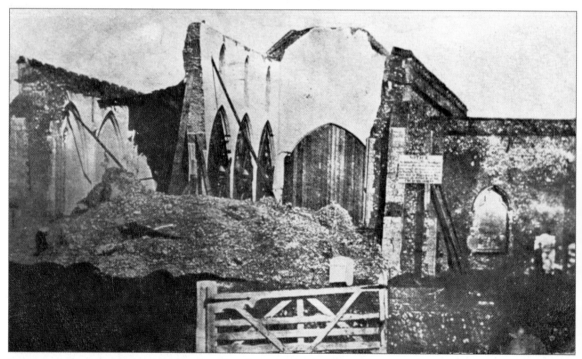

This postcard shows the result of a disaster when St Peter's Church tower at Thurston fell onto the nave in March 1860. Standing 75ft high, it had no foundation. Fissures had been noticed three years previously and repaired with iron ties. Ten days after this disaster the remains of the nave collapsed. Over £3,500 was collected for a building fund, and the church was reopened in October 1861. (*Pawsey*)

St Peter's Church, Thurston, in 1911, showing the successful restoration. (*Pawsey, author's collection*)

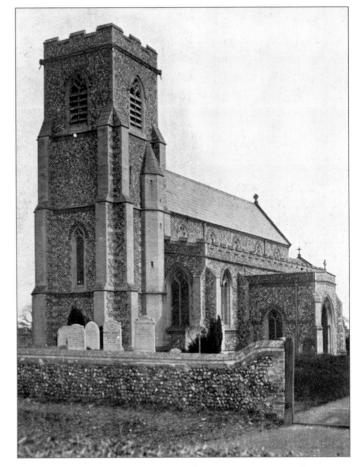

Tostock village green, postmarked 1910. The front of the two houses on the left have been dated to the early seventeenth century; they are now well looked after. The building on the far right was built during 1868 and 1869 as a Primitive Methodist chapel. David Rosier, a tailor, promoted the movement in Tostock until his death in 1910, and was probably the driving force behind the chapel. Having closed in 1982, it is now a private house with an attractive garden. (*Pawsey*)

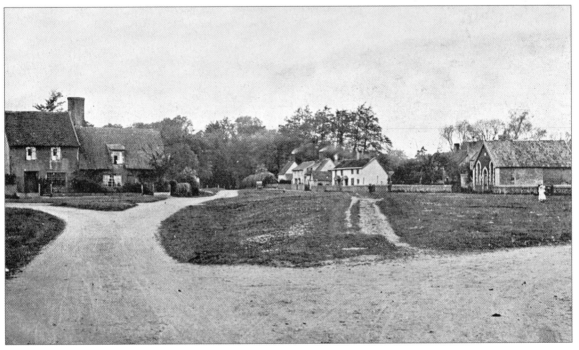

A postcard of the Dog Inn, Norton, postmarked 1904. This pub is documented from 1855. (*Pawsey*)

The Street, Norton. The single-storey building (right) was a reading room. Intended as an educational alternative to the village pub, these served as early libraries, often providing indoor recreation and a supply of coffee. The Reading Room movement was popular between 1875 and 1901 when a Suffolk Village Club and Reading Room Association operated. They seem to have declined from the 1920s: this was sold for conversion into a house in 1946. Over half the villages in Suffolk probably had a reading room, yet they are seldom remembered. (*Pawsey*)

Early examples of council housing on the Ixworth Road, Norton. Thedwastre Rural District Council decided to build working-class dwellings at Norton in September 1917. In December 1920 (after the passing of the 1919 Housing Act) Winkworth & Winkworth, builders, were awarded the contract to build thirty new houses here. They were probably ready for occupation by the next September, when a water supply was laid on. (*Joe Wakerley, Bury Bookshop*)

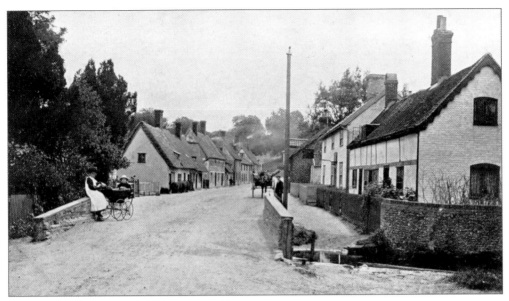

The Street at Pakenham, facing east, *c.* 1903. At that time there were five pubs in the village. Only the Fox (the first two-storey building to the right) still functions; the single-storey building beyond it was a reading room and coffee room presented to the village by Sir Walter Greene. The bridge has since been widened to extend the width of the street. The river became lifeless and unattractive, but in 1975 it was dredged, cleaned and revitalised. Pakenham is one of Suffolk's most conservation-minded villages: in 1987 the parish council set up a conservation and footpath group; and by 1990 it had planted a mile of hedgerow and eighty trees, and had opened a circular footpath walk. (*Pawsey*)

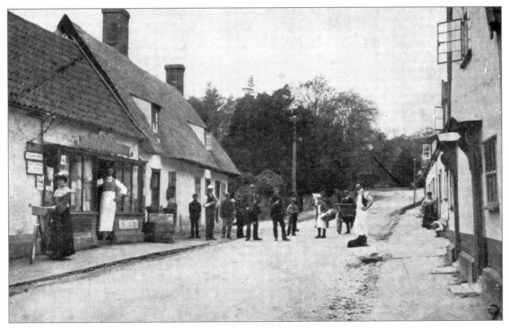

The west end of Pakenham Street, postmarked 1904, showing the village post office and several local residents. At that date Charlotte Fuller was postmistress, also running a grocers' and drapers' shop here. The post office is now a house; the adjoining house has since been rebuilt, but in keeping with the old building. (*Pawsey*)

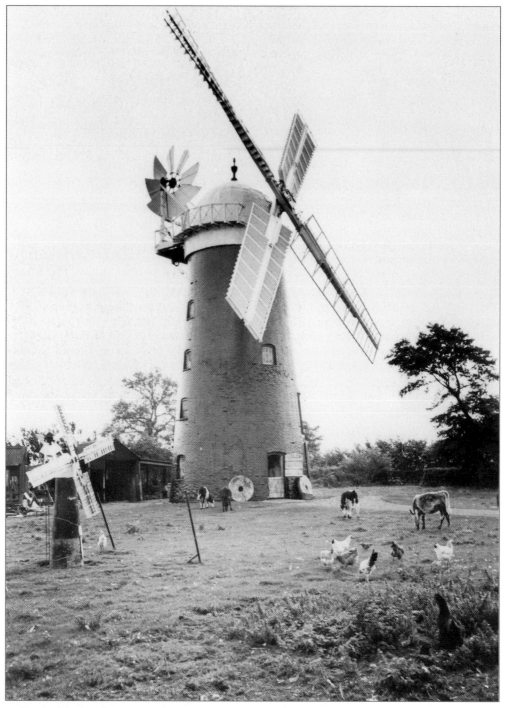

Pakenham windmill, built in 1831, stands 80ft high. In 1885 William Fordham bought it, and in 1920 it passed to his son-in-law Sidney John Bryant. The Bryant family kept it in working order, making animal feed for their farm (driving it with an engine when wind was low). Between 1961 and 1963 it was renovated and restored to full working order with grants from Suffolk County Council and the Ministry of Works (on condition that it continued to work). There is a working watermill nearby; Pakenham is the only parish in England to have both a working windmill and watermill. (*Suffolk Jewellery and Antiques*)

The Street, Stowlangtoft, on a card postmarked 1922. The buildings to the right were built as almshouses for four poor widows, probably in the seventeenth century, but are now private houses. (*Pawsey*)

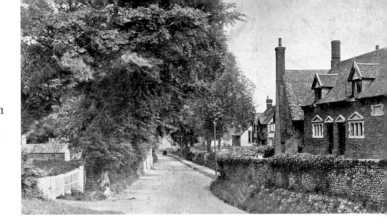

Stowlangtoft village shop and post office. The shopkeeper stands in a pleasantly cultivated front garden: he must have been a member of the Tuck family, who appear as postmasters and shopkeepers from the 1870s, when the post office opened, until the 1930s. (*Pawsey*)

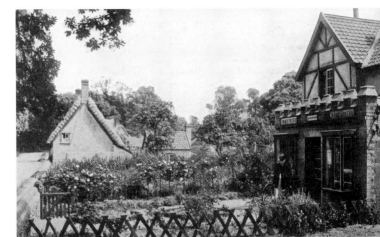

Stowlangtoft Hall was built in 1859 for the Wilson family in an Italian style that was fashionable at the time. It is now a home for the elderly. (*Author's collection*)

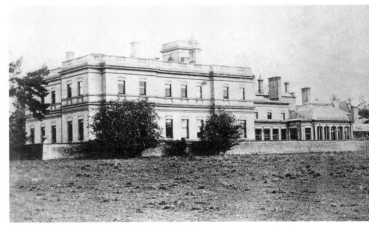

Flooding in Stowlangtoft in 1912. August was a particularly wet month, and on the 24th 4½in of rain fell in 16 hours. Floods were reported all across Suffolk. At Stowlangtoft a tumbrel was crossing a bridge when it collapsed; the passengers survived, but the horse was drowned. (*Suffolk Jewellery and Antiques*)

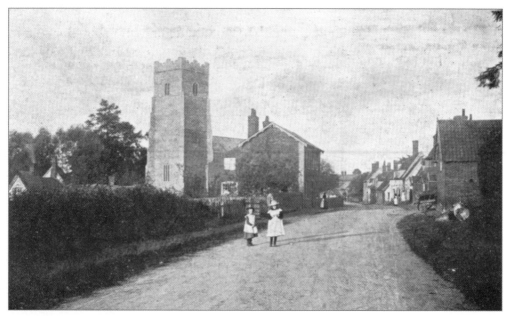

When this photograph of Badwell Ash was taken at the start of the twentieth century the photographer was standing on the western edge of the village. Since the 1960s modern housing has been built behind this point, but, apart from a modern extension to the house on the left, this view has not changed greatly. In about 1980 the building in the right foreground was replaced by a similar structure, partly constructed from re-used materials, which is now a fish and chip shop. (*Pawsey*)

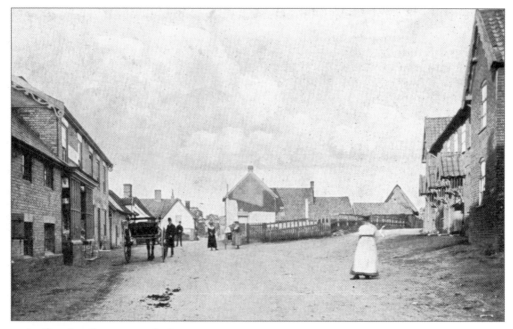

Badwell Ash village centre looks somewhat down-at-heel in this photograph, also taken early in the twentieth century. The house in the left foreground has been replaced, but most buildings shown here still stand, although they are now generally much better cared for: the village shop (to the left) still functions, retaining the frontage shown here. The terrace to the right is known as Barrack Cottages, a common name for rows of houses at the time. (*Pawsey*)

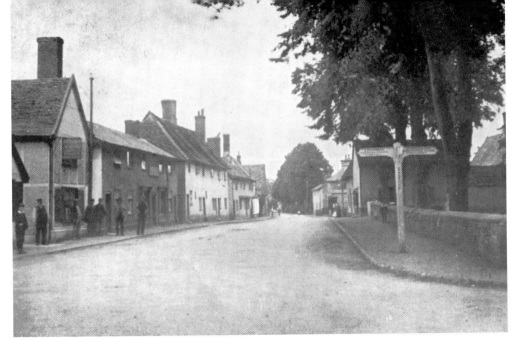

This view of the High Street, Walsham le Willows, shows how prosperous the village was in Tudor times. The Six Bells Inn (left foreground) is worth visiting for its timber frame. In 1523 it was the 'newly built' home of the Vincent family, wealthy mercers. The large white building beyond these was built in about 1500 as a Guildhall for the Holy Trinity, John the Baptist and St Katherine Guilds – religious and social clubs (and friendly societies). Such guilds were dissolved in the sixteenth-century Protestant Reformation, and by the eighteenth century the Guildhall had become a workhouse. When this picture appeared in *West Suffolk Illustrated* (1907) it was divided into 'tenements inhabited by poor people'. (*Pawsey*)

The Causeway at Walsham le Willows still presents an idyllic rural setting. The white building (right foreground), known as The Priory, was so named because it was the manor house of Ixworth Priory, which owned property here. It later became the vicarage. The Priory Room, the small one-storey building in front of the church tower, was built as a church hall in 1902. (*Author's collection*)

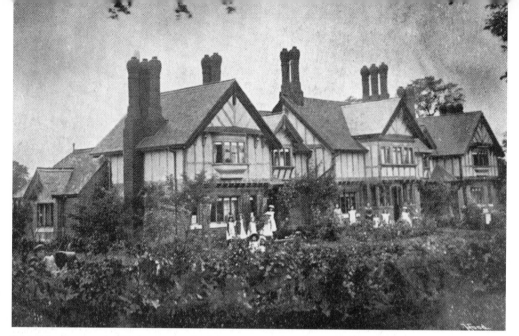

John Martineau, the Victorian Lord of the Manor, built model cottages in Walsham le Willows (inspired by Charles Kingsley's similar project at Eversley in Hampshire) to show how high-quality houses could be made for the working classes. Called New Cottages, these houses were built in 1879 at a cost of £1,080 6s 1d. The first occupiers were a shoemaker, a bricklayer and a ploughman (and their families). Improving texts are carved on the timber frames:

Be not wise in thine own eyes: Fear the Lord and depart from evil.
As a tree falls so shall it lie: as a man lives so shall he die
Better is little with the fear of the Lord than great treasure and trouble therewith. (*Pawsey*)

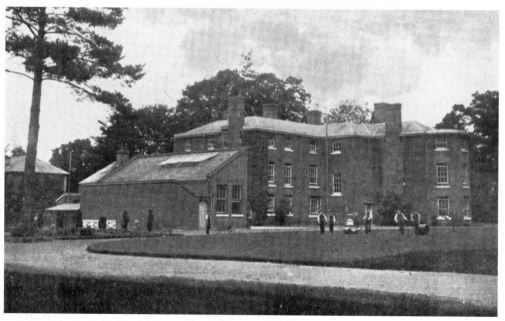

The Church of England Society for the Housing of Waifs and Strays acquired Walsham Hall in 1896. Forty destitute or abandoned children were cared for and given a new start here, one of over a hundred such houses that the Society ran. The organisation has continued as The Children's Society. The Parents' National Education Union later turned it into a Progressive School. Willow Court was built on the site in the 1970s. (*Pawsey*)

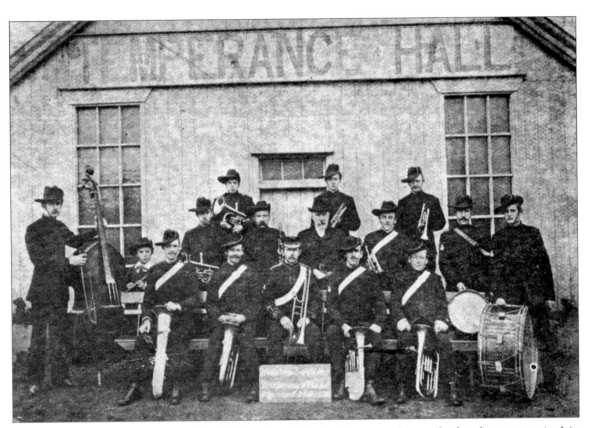

Walsham le Willows Temperance Band. The placard in the foreground says the band was organised in October 1893. The photograph was taken in 1906 in front of the Temperance Hall, which had been built four years earlier, and was a village hall until the Victory Memorial Hall opened in the 1950s. Left to right: Frank Nunn, double bass; Leonard Finch, piccolo; Arthur Landymore, bombardon; Arthur Death, tenor horn; Frank Moore, tenor horn; Harry Cocksedge, bass; John Finch, clarinet; Wilfred Nunn, trombone; Harry Nunn; Frank Sayers, cornet; Harry Finch, baritone; Harry Hubbard, cornet; Bill Smith, cornet; Herman Lord, baritone; Philip Finch, side drum; Oscar Frost, bass drum. (*Suffolk Jewellery and Antiques*)

St John's Church, Stanton. The tower stands right against the west boundary of the churchyard, with the result that a passage was built under the tower to allow religious processions to walk around the church. The Domesday Book recorded two churches in Stanton. They were both rebuilt in the fourteenth century. After 1554 they shared the same priest and the parishes were united in 1756. St John's passed out of use and the roof was removed in 1962. The remains are now in the care of the Churches Conservation Trust, a worthy organisation that takes care of disused churches. (*Suffolk Jewellery and Antiques*)

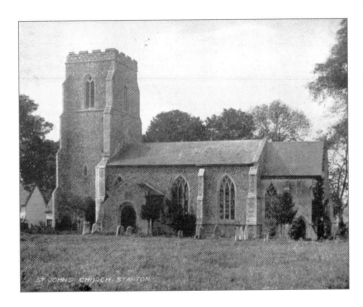

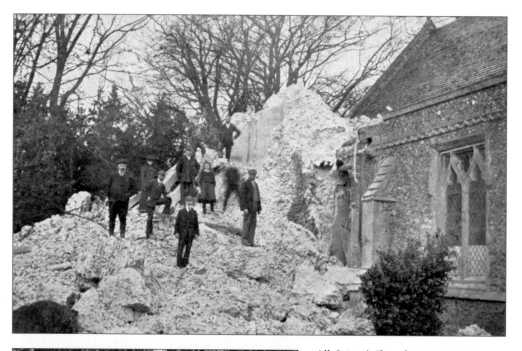

All Saints' Church at Stanton was one of twenty-two Suffolk churches with a south-west tower. Cracks had been noticed in the structure, but its sudden collapse just before 10 p.m. on Monday 5 March 1906 was a surprise, as the Rector and Rural Dean had inspected it that afternoon. The sexton normally wound the clock at 10. Fortuitously he had wound it early that day. Postcards of the disaster were printed quickly: this card was posted on 14 March! (*Pawsey*)

After the tower collapsed one church bell was hung in a tree in the churchyard until a new timber-framed belfry was built over the remains of the tower in 1956. (*Joe Wakerley, Bury Bookshop*)

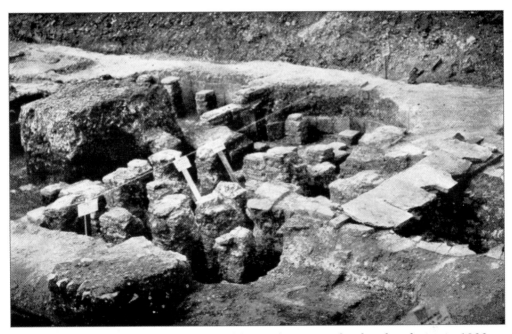

Stanton Chair Roman Villa was discovered by Basil Brown, a local archaeologist, in 1933 on Stanton Chair Farm, and excavated over the following nine years. The villa was built at the end of the first century AD. Burnt down and rebuilt in the mid-second century, occupation continued until the late fourth century. This shows the hypocaust or heating vault of a bathhouse, with a furnace to the right. 'Chair' derives from a word meaning 'bend in the river'. (*Pawsey*)

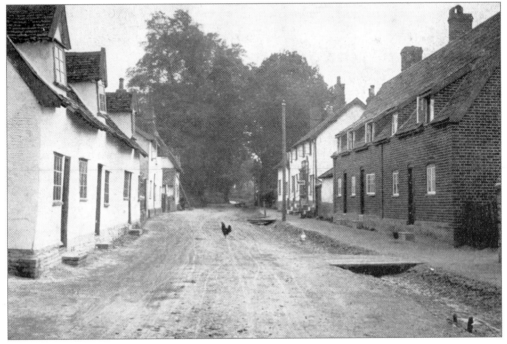

The Street in Stanton in about 1903. A stream that runs through the village appears to have become an open drain. Known as the Groop, it was covered and channelled in 1965. (*Pawsey, Suffolk Jewellery and Antiques*)

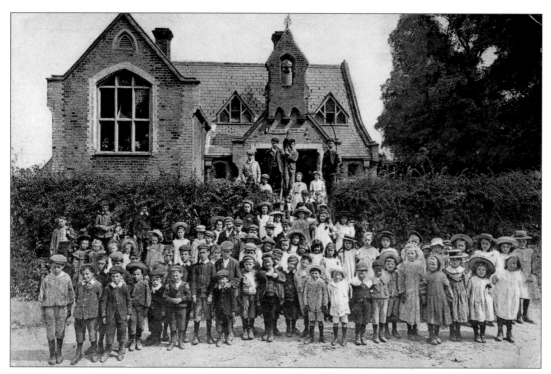

A postcard of Wattisfield village school and eighty-six pupils made by Jolly, the village shopkeeper, in 1905. The village's population was then 408, of which one-fifth were children of primary school age. The school had been built in 1862, and it may not surprise the reader to know that it was extended to the south (right) in 1909. The school closed after the summer term in 1986, when fewer than twenty children attended. After lying empty for ten years it was converted into houses. (*Author's collection*)

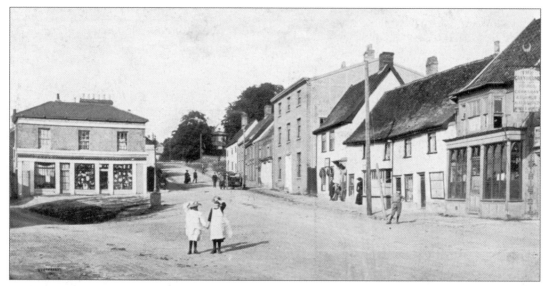

Botesdale, Rickinghall Superior and Rickinghall Inferior are separate parishes, but the three villages run along one long street to form a single village. This photograph shows Botesdale Market Place, looking northwards, along Crown Hill, as shown in *West Suffolk Illustrated* (1907). The market ceased to operate in the nineteenth century, but shops and the Greyhound Inn still operate, many retaining the frontages shown here. (*Pawsey*)

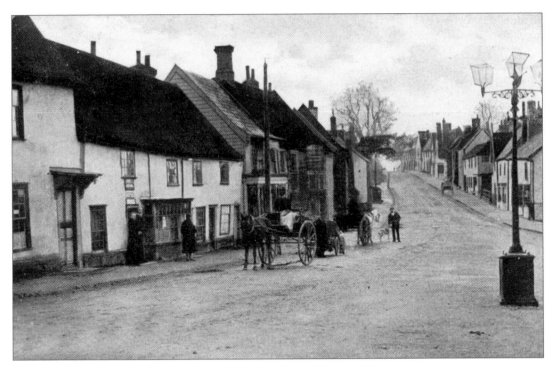

Botesdale Market Place facing south, towards Rickinghall Superior, showing a rather attractive and irregular range of old houses, some of which have been preserved to present a charming little townscape. The shop in the left foreground is now a fish and chip shop. (*Pawsey*)

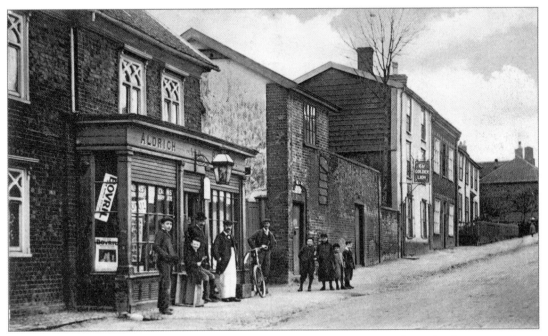

Aldrich and Bryant's shop appears in trade directories between 1892 and 1933. The postcard was published by the shop (and printed in Saxony) to publicise their business. The building survives, although the shop frontage has been removed. The Golden Lion pub in the background is now a private house. (*Suffolk Jewellery and Antiques*)

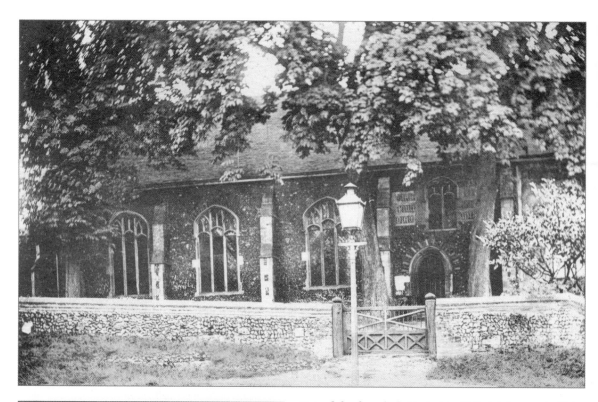

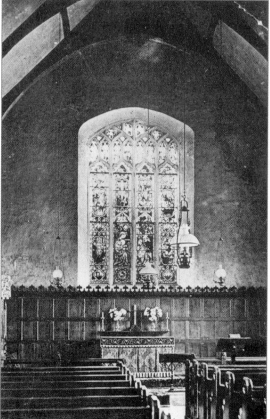

Botesdale chapel, dedicated to St Botolph, was built in 1442. In 1561 it was turned into a grammar school, and sent pupils to Cambridge University. A seventeenth-century headmaster, Sam Leeder, was pilloried for speaking against King William III. A famous Old Boy was Hablot Brown, better known as Phiz, illustrator of Charles Dickens's novels. The school closed in 1878, and in 1883 the chapel returned to its original purpose as a place of worship. (*Jennifer Cordeaux, postcards published by Aldrich and Bryant*)

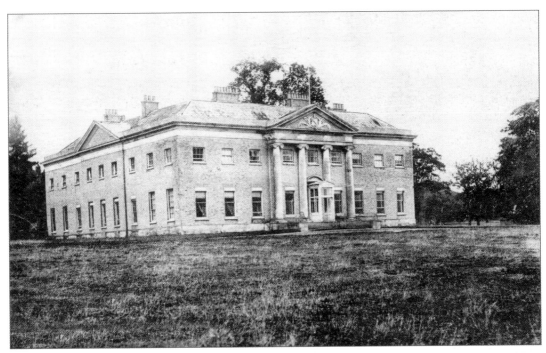

Redgrave Hall was built in 1554 as the principal Suffolk residence of the Bacon family. In 1763 Capability Brown rebuilt it for the Holt family, using Woolpit bricks. Troops were stationed here during the Second World War, but it was demolished in 1946. (*Author's collection*)

This section of Church Street at Bardwell was known as Coal Lane because coal was distributed here. A local benefactor left 28 acres on which the local poor could gather fuel for fires: the land was later rented, and the rent used to buy coal. Bell Cottage, to the left of the church tower, dates from the sixteenth century, but was refaced in the nineteenth century. Three generations of the Cawley family who lived here were sextons from the mid-eighteenth to the early twentieth century. (*Barrie Fordham and Fordham's Garage*)

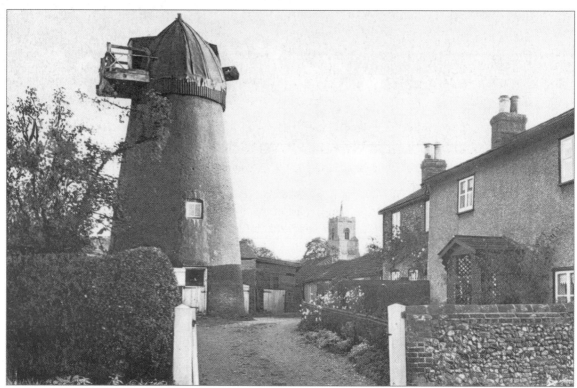

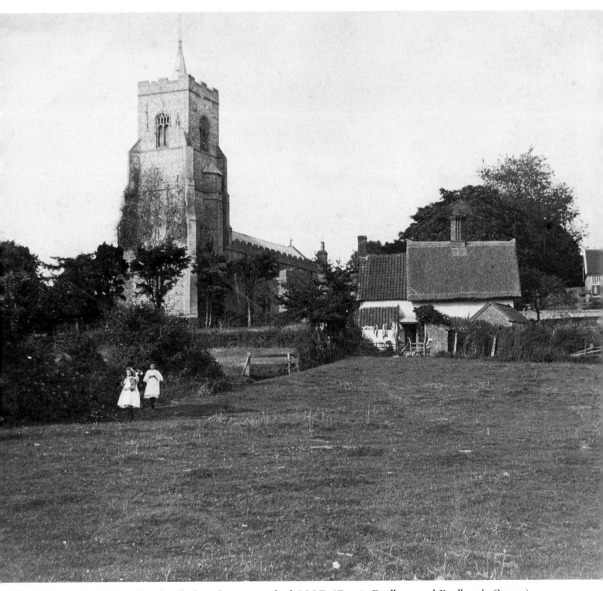

Above: View over field to Bardwell church, postmarked 1907. (*Barrie Fordham and Fordham's Garage*)

Opposite, above: This interesting ensemble of timber-framed and plastered cottages in Low Street, Bardwell, are now all Grade II* listed buildings. The central part of the house to the right was a fifteenth-century hall house; the houses beside it (foreground and background) were added in the seventeenth and eighteenth centuries. (*Suffolk Jewellery and Antiques*)

Opposite, below: Bardwell windmill was built in the 1820s; a beam in the cap bears the date 1829. Although the sails were removed in 1925 the machinery remained intact, and was occasionally driven by a petrol or oil machine. In 1984 the mill was acquired by James Waterfield, who had the sails replaced and began milling flour commercially. Unfortunately the new sails were destroyed in a storm in 1987. A local organisation, the Friends of Bardwell Windmill, is now working with the Wheeler family to restore it to working order. (*Barrie Fordham and Fordham's Garage*)

An attractive view of Coney Weston blacksmith's shop from *West Suffolk Illustrated* (1907), showing a range of agricultural machinery that may be awaiting repair. The 1901 census listed George Boswell (aged 53) as the blacksmith and his son, also called George (aged 15), as his apprentice. The blacksmith's house (left background) still stands, but the smithy has vanished. (*Pawsey*)

Coney Weston: the post office, looking very rural and picturesque, on a card postmarked 1928. (*Author's collection*)

4

The South-East

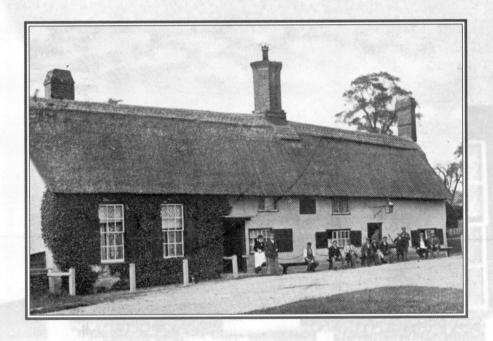

Sicklesmere was a hamlet between Great and Little Whelnetham, but has expanded to become larger than its parent villages. This postcard shows the Rushbrooke Arms pub in about 1900. At that date George Barton was landlord, but by 1904 it was run by William Grimmer. This pub was called the Wagon in the eighteenth century, and locals still use this name. In 1987 it was extended with the addition of a fifteenth-century barn from Hitcham. (*Pawsey*)

This area stretches into High Suffolk, the central plateau of Suffolk. High Suffolk is perhaps a superlative of agricultural productivity and central geographical location: the region seldom rises to more than 200ft above sea level. It possibly lacks a clear regional identity; it is difficult to think of many defining features to characterise the villages in this area. Although the main Bury–Sudbury road and the Bury–Melford railway line crossed this area, settlement did not necessarily follow the main roads (although Sicklesmere only developed because it stood on a turnpike road). Cockfield had a railway station, yet settlement in this parish is widely scattered with no definite centre or focus; Rougham and the Bradfields are a disparate variety of small settlements; Thorpe Morieux is widely strung out. But Beyton lies firmly set around a large village green; Rattlesden is a nucleated settlement (even if the green in the village centre is still liable to flood); and Woolpit, drawing on its situation on the main Bury–Ipswich road, is centred on a small market place (even if the market had ceased to trade by the nineteenth century).

Yet this area contains its attractions. Woolpit, Rattlesden and Hessett are among the most unusually beautiful villages in Suffolk, while Cockfield has much to reward anybody who persists in navigating its eight greens. The loss of Rushbrooke Hall was a tragedy, but Brettenham Hall, Drinkstone postmill and the Rattlesden whalebones are some of the region's surprises.

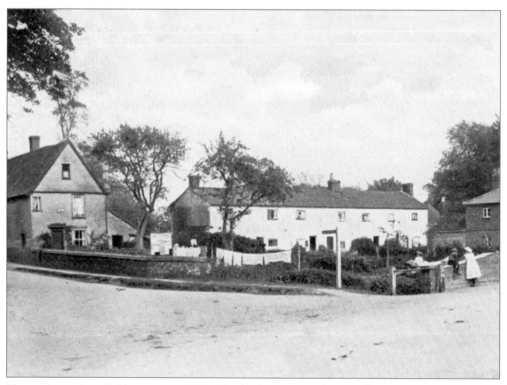

The main road at Sicklesmere, *c.* 1903. The bridge crosses the marsh (or mere) that gave the village its name. This has shrunk and now runs through a tunnel under the road, so that passing motorists would hardly suspect its existence. The photograph was obviously taken on somebody's washing day! (*Pawsey*)

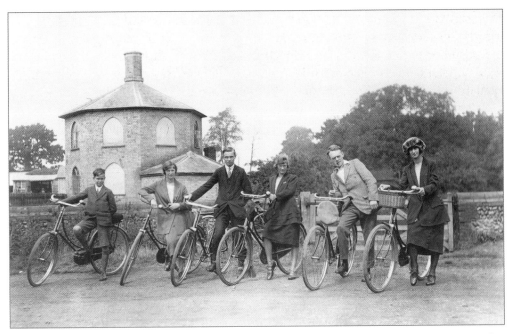

Sicklesmere. I know nothing about this amusing group of cyclists, or why they posed for this photograph. The building in the background is an eighteenth-century tollhouse that collected payments from people using the turnpike road to Bury.

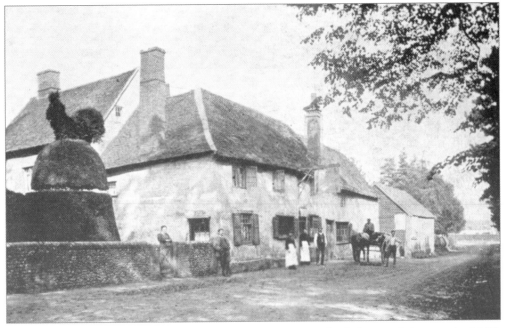

The Manger Inn at Bradfield Combust is mentioned in a will of Thomas Robertson in 1660. When this photograph appeared in *West Suffolk Illustrated* (1907) the landlord was Harry Howe. Originally known as Little Bradfield, the village was one of the Abbot of Bury's favourite residences. In 1327, when local people rebelled against the Abbot's rule, they burnt his mansion. Ever since the village has been called Bradfield Combust from the fire (or combustion). (*Pawsey, Joe Wakerley, Bury Bookshop*)

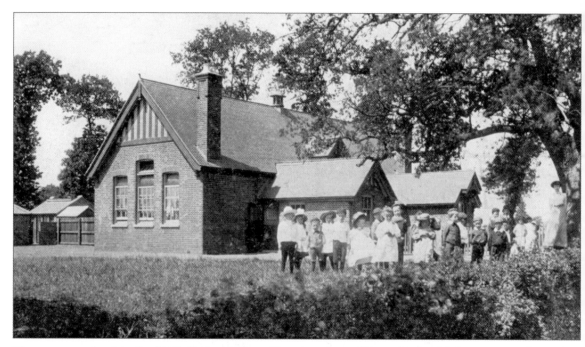

There was a school in Bradfield St George from Victorian times. When this establishment opened in 1910 the headteacher was Mr R. Thompson. A female assistant poses with the children (right). In the Second World War it billeted soldiers and then housed evacuees. After 1949 it took children from other villages, but piped water was not laid on until 1951. In 1986, when only seventeen children attended, it was merged with Cockfield School, despite a petition signed by 170 people. It is now a private house. (*Pawsey*)

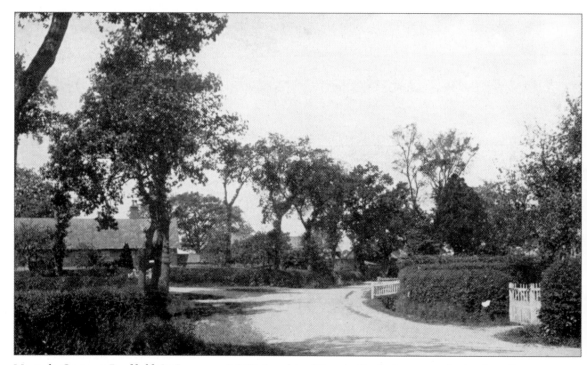

Maypole Green at Bradfield St George, *c*. 1903. Local tradition holds that a maypole stood on the open area to the left of the road. (*Pawsey*)

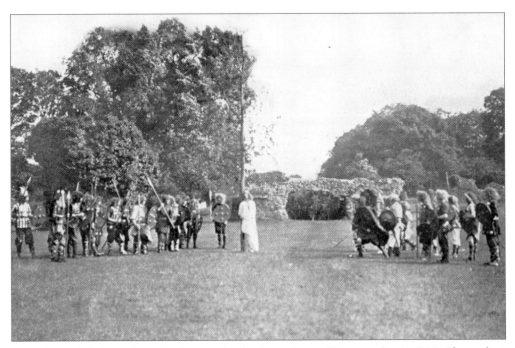

The Vikings killed St Edmund, the last Anglo-Saxon king of East Anglia, in 869. The earliest account of the event located his death at Haeglisdon. In 1978 Stanley West, the Suffolk County Archaeologist, established that this was at Pitcher's Green in Bradfield St Clare. This shows a dramatisation of the event at the Bury Pageant of 1907. (*Pawsey, author's collection*)

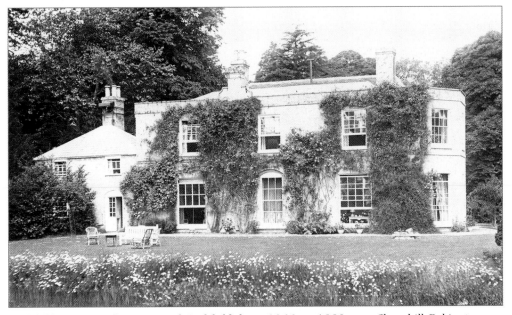

Cockfield Rectory. The Rector of Cockfield from 1866 to 1889 was Churchill Babington, an archaeologist, classicist and scientist. His wife was a cousin of Robert Louis Stevenson, who stayed here in 1873, when aged 22. The Babingtons' friends included Sidney Colvin, a critic, who recognised Robert's abilities and recommended him to other literary figures, and Frances Sitwell, a famous beauty, who inspired his mind. Robert Louis Stevenson considered that his stay here started his literary career. (*Joe Wakerley, Bury Bookshop*)

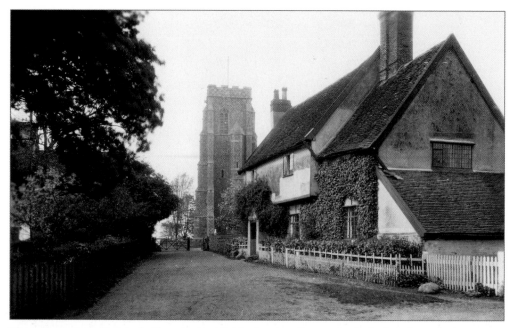

The approach to St Peter's Church, Cockfield, showing the particularly fine fourteenth-century church tower. Church Cottage in the foreground was originally the Church House, a forerunner of the village hall, used for parish festivals and holidays. William Ludlam, rector of Cockfield from 1767 to 1787, was a leading astronomer. During a restoration in 1999 it was found that he had bored holes in the tower wall for his telescope. William Ludlam was on the board that investigated Harrison's Chronometer, the first truly accurate clock, an episode in scientific history made famous by Dava Sobel's recent bestseller, *Longitude*. (*Joe Wakerley, Bury Bookshop*)

Cockfield station stood on the Bury–Melford railway line. It opened in 1865 as a goods siding, and took passengers after 1870. Passenger services ceased in April 1961, and the line finally closed four years later. The station became a coal yard for a while. It is now empty and unused, but is at least preserved. (*Joe Wakerley, Bury Bookshop*)

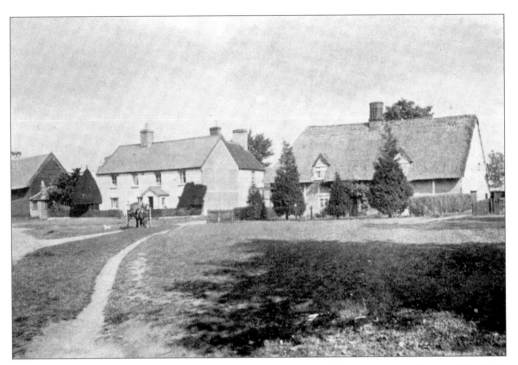

Cockfield is strung out around eight greens: Buttons, Colchester, Cross, Great, Old, Hall, Smithwood and Windsor Green. This view of Cross Green appeared in *West Suffolk Illustrated* (1907). The buildings shown here still stand, but the barn to the left has now been turned into a house. (*Pawsey*)

Thorpe Morieux Manor House in 1914, looking towards the church, an attractive setting that is still enjoyable today. The name Morieux comes from a medieval family who were lords of the manor: the name is now pronounced Thorpe Moroo (to rhyme with Peru). (*Joe Wakerley, Bury Bookshop*)

Brettenham Hall dates from the seventeenth century. In 1830 it was the residence of Napoleon's brother, Joseph Bonaparte, the former king of Spain. In 1956 it was taken over by Old Buckenham Hall School. Founded in Lowestoft in 1862, this is one of the oldest (and most travelled) preparatory schools in England. (*Upper: Joe Wakerley, Bury Bookshop. Lower: Burrell, author's collection*)

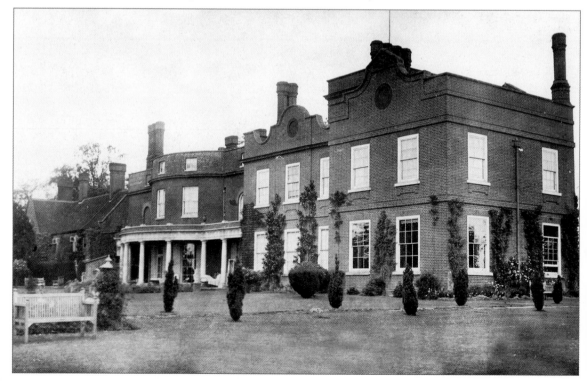

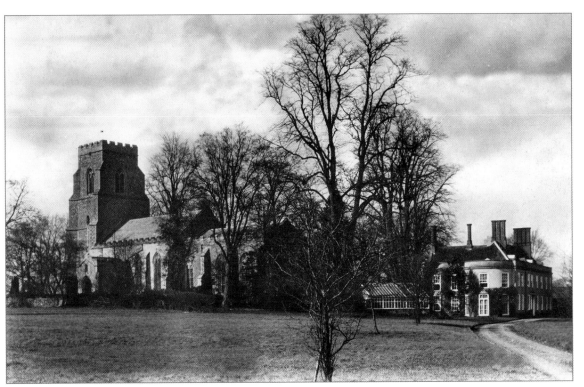

Buxhall church and rectory in a pleasantly rural setting. The Rectory was built in 1710, when 'squarsons', or country parsons, were often among the local gentry. (*Author's collection*)

Felsham Village Green, evidently taken in a high wind judging by the appearance of the three schoolgirls to the right! The buildings in the centre of the photograph still stand. (*Joe Wakerley, Bury Bookshop*)

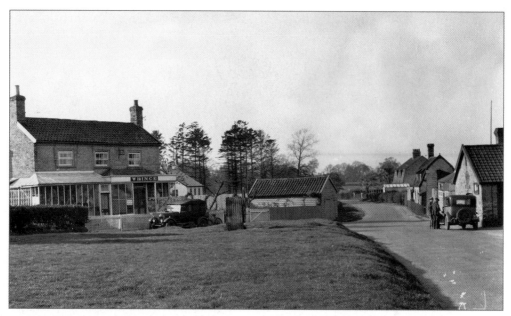

Felsham Village Green, on a card postmarked 1937. The building to the left, beside the car, was a blacksmith's shop, which has now been converted into a garage. W. Hince's shop is now a private house. The present proprietor of the garage remembers that when he arrived at Felsham in 1952 this was the only water supply in the village. (*Joe Wakerley, Bury Bookshop*)

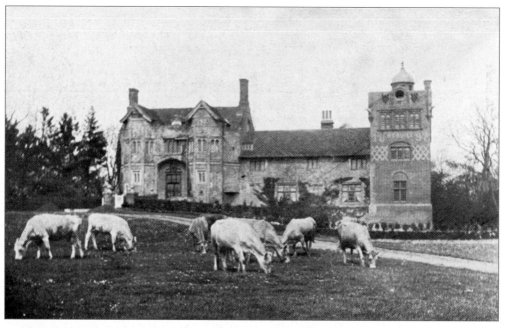

Gedding Hall, from *West Suffolk Illustrated* (1907). The Chamberlain family, lords of the manor between 1357 and 1582, probably rebuilt it during Henry VIII's reign. In 1897 Arthur Wakerley, a former mayor of Leicester, bought and restored it, adding the square tower on the right. The cows in the foreground were the last herd of Suffolk Dun Polls (polled cattle lack horns). They were regarded as excellent milk producers. The breed is now extinct, but in the early nineteenth century they were crossbred with the Norfolk Red (also now extinct) to produce the Red Poll. (*Pawsey*)

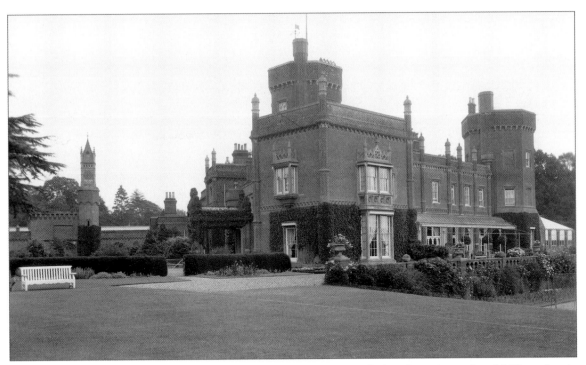

Rougham Hall was built in 1820. It received a direct hit from a firebomb in September 1940, and only overgrown ruins now remain. (*Joe Wakerley, Bury Bookshop*)

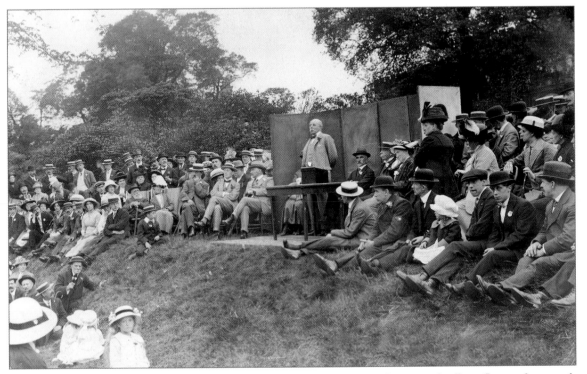

Sir George Agnew bought Rougham Hall in 1904. He presided over the annual village flower show each July. This may be a photograph of the show on 19 July 1914, which included races, competitions and maypole dancing. (*Joe Wakerley, Bury Bookshop*)

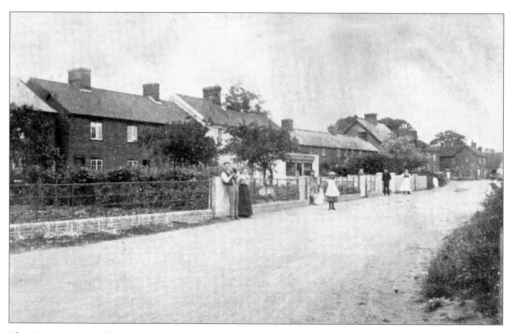

The Street at Rougham, *c.* 1903. The village post office still operates in the central house. The garden railings (left) were removed to help the war effort in the Second World War. The Bennett Arms pub stands around the corner from these houses, and there was a local joke that men returning from the pub at night used the railings to navigate their way home! (*Pawsey*)

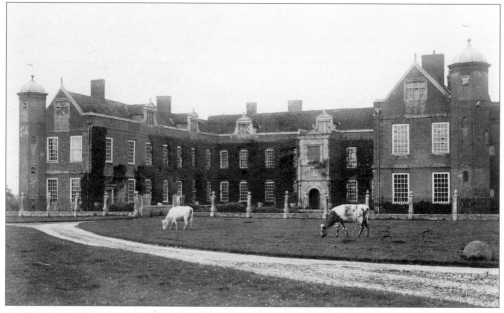

Rushbrooke Hall, postmarked 1909. This is possibly Suffolk's most beautiful house, with three wings, each 176ft long. It is thought that the east wing (right) was built for the Jermyn family in 1500. Sir Thomas Jermyn became 'the best housekeeper in Suffolk' during Henry VIII's reign; the central and west ranges were under construction at his death in 1552. Legend held that the Hall was haunted by a murdered lady whose body was thrown into the moat. It was empty in 1961, when it burnt down. (*Author's collection*)

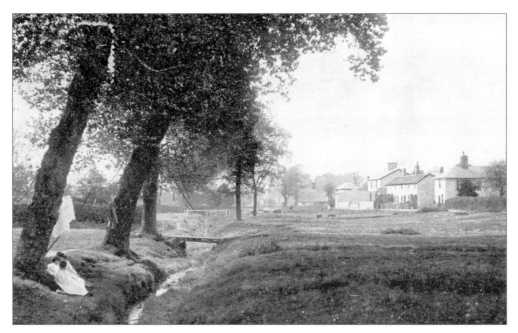

Beyton. In his 1941 *Guide to Suffolk* in his King's England series Arthur Mee observed that Beyton 'has about 100 ash trees on its green, a stately company, their branches rising above the quaint tiled cottages'. Since the diversion of the Bury–Ipswich road to bypass Beyton Arthur Mee's comments might apply again. The stream still runs through the green, crossed by small footbridges, and flanked by trees. A small children's playground has recently been installed at the end of the green. (*Pawsey*)

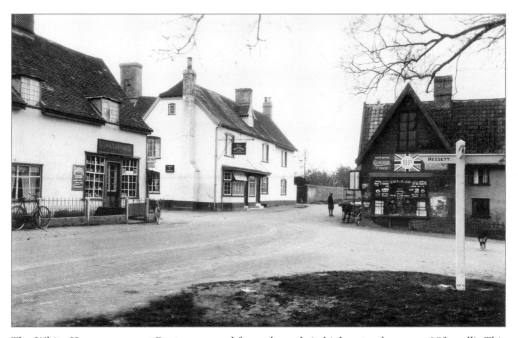

The White Horse corner at Beyton, named from the pub (which extends over a 60ft well). This card, postmarked 1941, shows Walter Harold Austin's grocery shop and general store (left), which traded from 1922. Rous's shop (right, behind the signpost), first mentioned in 1908, was rather more unusual – a bicycle shop. (*Joe Wakerley, Bury Bookshop*)

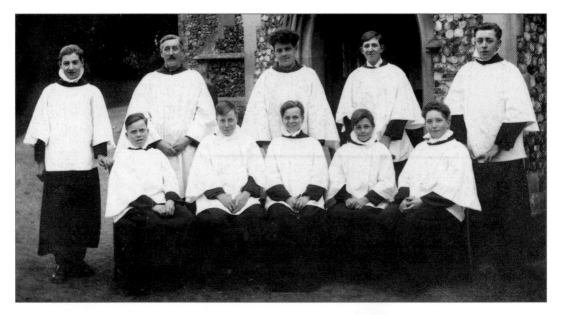

Above: Beyton church choir. (*Pawsey, Joe Wakerley, Bury Bookshop*)

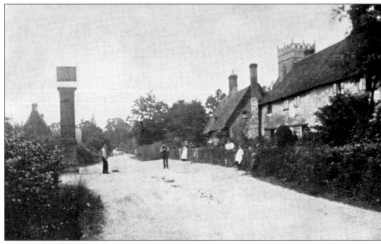

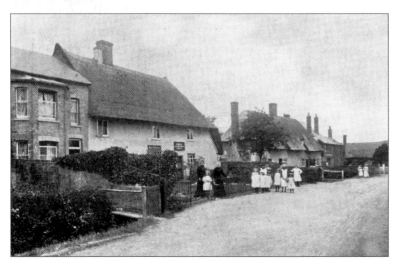

Postcards of the main street at Hessett, postmarked 1904 and 1905. A brook that runs along the west side of the main street was still uncovered at the time and many houses were reached by bridge. The post office continued in business until 2003. Another feature of the street is the Six Bells Inn sign on a high brick column. Many older houses in Hessett have been preserved, and Bill Sargeant, a local craftsman, has recently pargetted their exteriors, improving their appearance in a traditional way. (*Pawsey*)

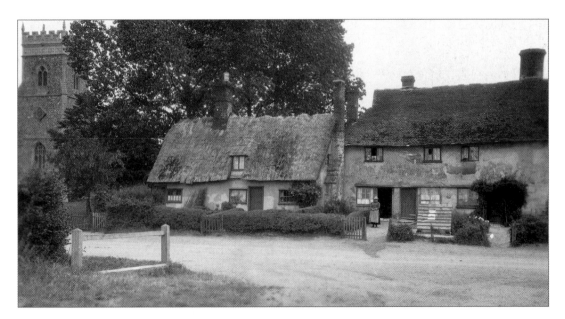

Hessett: this card, postmarked 1924, shows a row of cottages near the parish church. St Ethelbert's Church displays outstanding stone carving and flint work. The view is perhaps of greater interest for the tumbledown state of the cottages: the thatch on the left cottage is decayed, while there is a big hole in the plaster by centre window of the right cottage. Also notice the timber well-cover (right of the woman). The houses are now well maintained and form most attractive residences. (*Joe Wakerley, Bury Bookshop*)

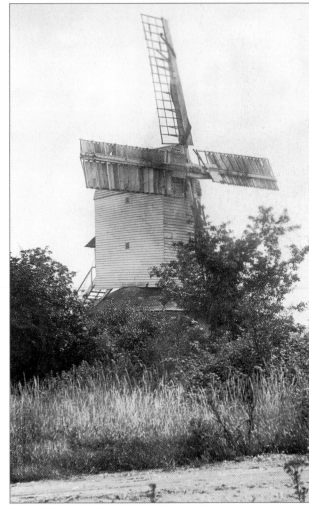

Drinkstone postmill ground corn commercially until 1973. It is known that the Clover family acquired it in 1774, but dendrochronology (tree ring dating) has dated many timbers to the sixteenth century, and the central post ring to 1587, suggesting that this is the oldest windmill in England. It stands on a farmstead with an eighteenth-century smock windmill, a miller's cottage and garden, animal sheds and agricultural storerooms converted from an army hut and a railway carriage, creating one of Suffolk's most important industrial archaeological sites. (*Joe Wakerley, Bury Bookshop*)

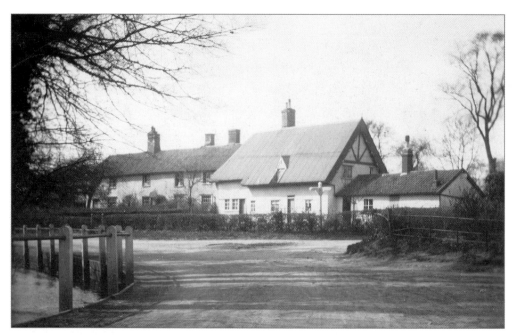

The blacksmith's house at Drinkstone. Now well looked after, the metal roof has been replaced by thatch. (*Joe Wakerley, Bury Bookshop*)

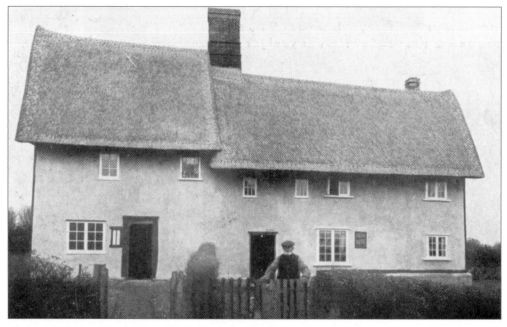

These cottages at Drinkstone were in danger of collapse when the Society for the Protection of Ancient Buildings bought and restored them in 1919. A.R. Powys, the Society's secretary, wrote *An Old Cottage Saved* (1921), showing how this was achieved at a fraction of the cost of erecting a new building: a timeless lesson for modern architects. This postcard was published to show the project's success. It was thought that the cottages were built between 1475 and 1525 as a priest's house. Unfortunately the cottages have recently been subject to unsympathetic and insensitive modernisation: new tile roofs and door entrances have been fitted, destroying the symmetry and harmony of the setting. (*Joe Wakerley, Bury Bookshop*)

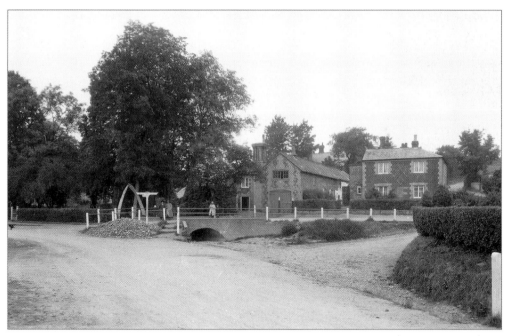

The stream running through Rattlesden. The whalebone arch (left of the bridge) was believed to have been brought here from the Great Exhibition of 1851. It deteriorated towards the end of the twentieth century, but a replacement was made for the village's Millennium celebrations in September 2000. (*Suffolk Jewellery and Antiques*)

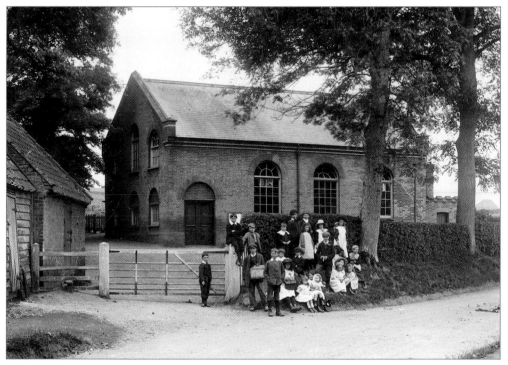

Rattlesden Baptist Chapel. Built in 1808, it was enlarged in 1815 and rebuilt in 1892. The chapel still maintains a thriving congregation, and was recently extended to the north (rear). (*Suffolk Jewellery and Antiques*)

Rattlesden Mothers' Union in front of the church, 28 May 1936. Left to right: Mrs Euston, Mrs Matter, Mrs Emberson, Mary Gladwell, Mrs Adams, Mrs Nunn, Mrs Deere, Mrs Lumsden (the headmaster's wife), Mrs Norman, Mrs Wilson (the rector's wife), Mrs Prew, Mrs Abbot, Evelyn Smith, Mrs Baker, Mrs Windsor-Parker, Kate Richer, Mrs Holmes, Mrs Welham, Kazia Teazle. (*Author's collection*)

This view of Woolpit market place, postmarked 1905, may have been printed to publicise Hicks' Bakery. Thomas Frederick Hicks was a baker and confectioner in nearby Elmswell between 1904 and 1916. The Institute (left of Hicks') was a social club and reading room: it is now a village museum. The Jubilee Pump (obscured by vegetation) was erected for Queen Victoria's Diamond Jubilee in 1897. Many houses shown here date from the fifteenth or sixteenth century. Generally regarded as one of Suffolk's most attractive villages, Woolpit is still a thriving community with eight shops in the market place. (*Author's collection*)

The Swan Inn at Woolpit in about 1903 (taken over by the Stanley family in about 1895). Dominating the west side of the market place, the Swan is mentioned in a village survey of 1577. The larger, three-storey extension was built in 1826, and the original inn was probably refaced at the same time. The frontage is an outstanding example of the use of Woolpit bricks, which were made in the village. (*Pawsey*)

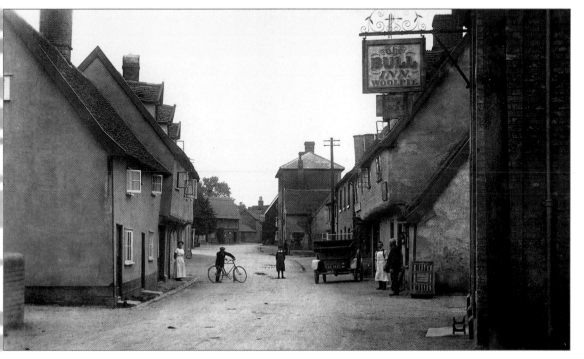

The Street at Woolpit, facing north. All the houses shown in this postcard still stand, although in several cases the plaster has been removed to show the underlying timber frame. (*Joe Wakerley, Bury Bookshop*)

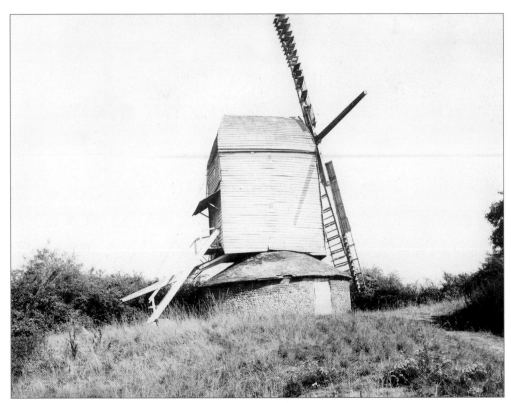

A windmill is known to have stood in Broomhill Lane at Woolpit in 1577 but the one shown here was probably built in 1675. From 1864 to 1933 it was owned by the Elmer family. Having fallen into disrepair, it collapsed in 1963. (*Author's collection*)

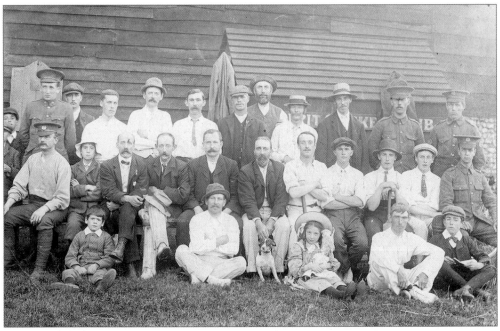

Woolpit Village Cricket Team: a note on the back says the picture was taken in 1909. (*Suffolk Jewellery and Antiques*)

5

The South-West

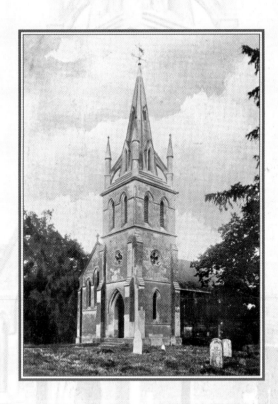

Westley Church as shown in *West Suffolk Illustrated* (1907). Built between 1834 and 1836, this was the first Church of England church made of concrete with a cast-iron roof. The Marquess of Bristol funded the building. The spire, which could be seen from the Marquess's mansion at Ickworth, was removed in 1961 in the mistaken belief that it was unsafe. In fact demolition proved costly and difficult. (*Pawsey*)

To the south-west of Bury St Edmunds there are two distinct geographical areas. The northern part of the region runs between Bury and Newmarket; villages at the west end of this area cannot avoid being drawn into the orbit of Newmarket, with its aristocratic horseracing connections (as is particularly obvious at Kentford). At the other end of the area, at Hartest, there are traces of the medieval clothing industry that was important in South Suffolk. Between these there are many villages, and several country mansions providing variety (especially the colossal stately home at Ickworth).

Suffolk's wide variety of rural settlements can all be found in this south-western corner. Wickhambrook is a thriving village, with a strong local identity, yet it has no obvious centre: it is spread out around numerous greens, and some of the most important village amenities (even the church) are separate from these. Barrow,

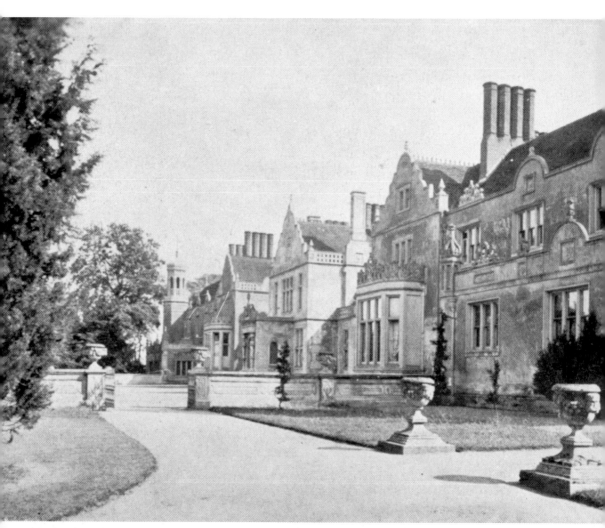

Hardwick Hall, the home of the Cullum family, was built in the seventeenth century, and enlarged in the nineteenth century. Regarded as a local showplace, it was demolished in 1925, although much of the impressive collection of art objects and books that were housed here were left to the Borough museum and library service. (*Joe Wakerley, Bury Bookshop*)

which also displays a strong sense of community, lies around a large village green, which shows an assortment of village architecture. Moulton possesses an obvious (and rather unusual) reminder of its importance in the Middle Ages in its fifteenth-century bridge. A brief look at Dalham shows how early settlers would have chosen to live there because of its location in a river valley. Denham is a scattered hamlet; Higham too was a hamlet on a byroad, but may have grown in importance when a railway station opened there. No trains have stopped at Higham station since 1967, yet the village is still a distinct entity. It even manages to run a village shop and there are regular services in the Victorian parish church (even if the local pub has been converted into a private house). Meanwhile, Hartest and Shimpling show how the Suffolk countryside still contains many little-known treasures.

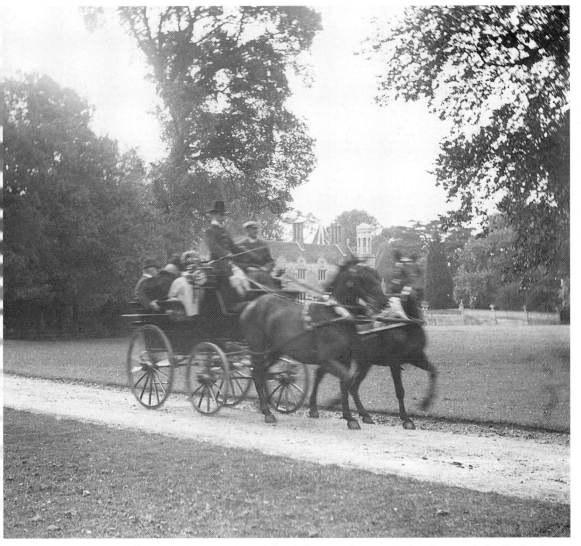

George Milner-Gibson-Cullum, the last member of the Cullums to live at Hardwick, posted this lively picture of his carriage driving through the Park in 1906. (*Author's collection*)

An avenue of trees in Hardwick Park. After Hardwick Hall was demolished the gardens were no longer cultivated, but the park remains as a public recreation area, still containing many notable trees. (*Joe Wakerley, Bury Bookshop*)

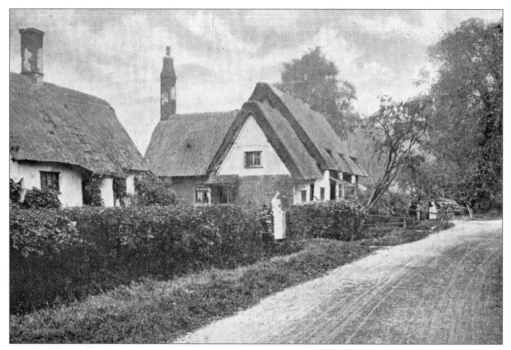

Hawstead. These cottages on the Bury Road at Hawstead, from *West Suffolk Illustrated* (1907), stand midway between the parish church and the village green in this widely strung out village. Pound Cottage (right) may date from the late fifteenth or early sixteenth century, while the other house (left) has been dated to the late seventeenth or early eighteenth century. Although tiles have replaced the thatch roofs, they are now Grade II listed buildings. (*Pawsey*)

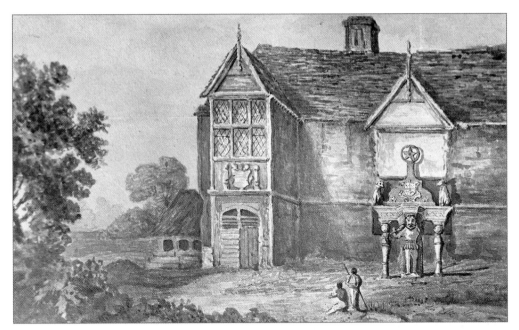

Hawstead Place was a moated courtyard house. In 1510 Sir Robert Drury obtained royal permission to improve it. Thomas Cullum bought the estate in 1656. His descendants preferred Hardwick, and Hawstead Place became a farmhouse. Parts either fell down or were pulled down, until only the north wing was left. This too was demolished in 1827, soon after this sketch was made. The statue of Hercules, made for Elizabeth I's visit in 1578, was moved to Hardwick Park, but was returned here in 1977 at Elizabeth II's Silver Jubilee. (*Joe Wakerley, Bury Bookshop*)

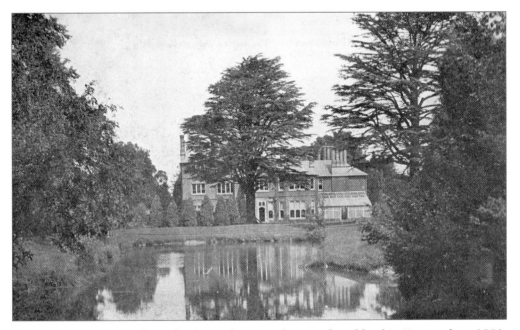

Nowton Court. James Oakes, a banker and yarn maker, purchased land in Nowton from 1801. His son Orbell Ray Oakes bought the manor in 1832. A cottage was rebuilt in a Tudor style by George French of London in 1839, and renamed Nowton Court. It is now a facility of Keio University in Tokyo, a leading Japanese educational establishment. (*Pawsey*)

The Street at Whepstead, showing the post office (centre, just behind telephone kiosk), from a series of souvenir postcards of Whepstead published for Archer Arnold, village postmaster from 1908. Whepstead post office closed in September 2003; this was reported in the local press as an example of the decline of rural services. There was some relief when a new post office opened in November 2003. (*John Cullum*)

Stone Cross Green at Whepstead, another souvenir postcard marketed by Archer Arnold. (*John Cullum*)

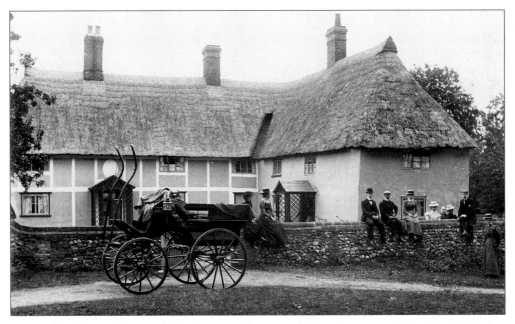

New Hall Farm at Whepstead. The identity of the people in the photograph is uncertain. They are probably the farmer and his family, who may be preparing for an excursion on the cart. (*John Cullum*)

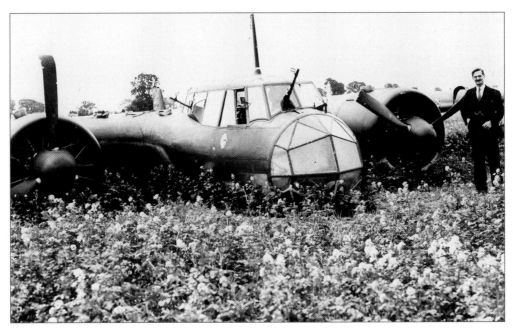

A German Dornier aircraft, shot down at Whepstead on 26 August 1940, at the height of the Battle of Britain. Riddled with bullets and flying at tree height on one engine, it dropped a bomb before crashing into a field of mustard. Two wounded airmen struggled from the wreckage, but the pilot was too badly wounded to leave the cockpit. The fourth airman, aged only about 16, was unhurt. Mr Boreham of the local Home Guard, a First World War veteran, approached with a pitchfork, accompanied by Mr Mingay, the farmer who owned the field. The airmen surrendered and were taken to hospital and military detention. Thomas Linford, editor of the *Bury Free Press*, stands by the wreckage. (*John Cullum*)

Horringer village green facing north, with the church just visible in the background. The lengthy green was not so neatly kept then as it is now. (*Joe Wakerley, Bury Bookshop*)

The north end of Horringer village green at the start of the twentieth century, showing the village school; the schoolchildren (and a postman) have obligingly posed for the photograph. At the time the headmaster, John Curtis, ran the school with two female assistants. I am uncertain if these are the ladies standing on the verge of the road (left). (*Pawsey*)

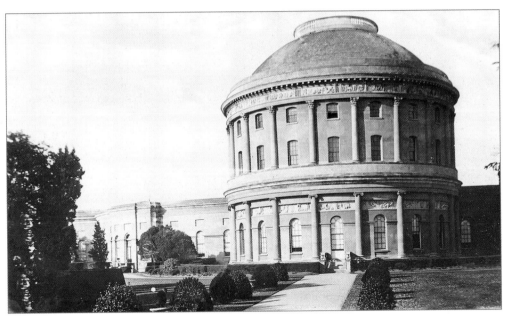

Ickworth, shown here just before the First World War, home of the Herveys, who became earls, and later marquesses, of Bristol. In 1792 the 4th Earl (who was also a bishop, and travelled the continent collecting art treasures) commissioned a suitably palatial house for an art-loving earl bishop. Ironically, Napoleon seized his collection in 1796. The house is difficult to photograph, as it is 700ft long. Construction was never finished: the west wing (left) was only made for symmetry, and was empty inside. In 1956 the Herveys presented Ickworth to the National Trust in lieu of death duties, and leased the east wing back. The National Trust were driven to threaten the 7th Marquis with eviction, for such pursuits as taking drugs, driving cars over lawns in the Park and indiscriminately firing air rifles. After his release from prison for drug offences, however, the marquis left of his own accord. (*Farringdon, Suffolk Jewellery and Antiques*)

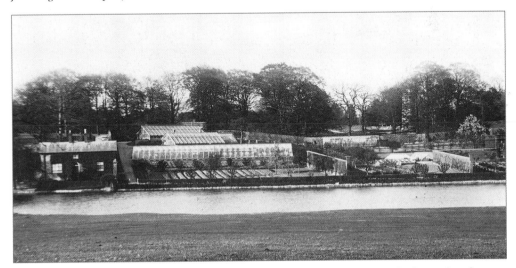

Running a country estate like Ickworth was a complicated enterprise, which employed many people who had to be cared for. Food supply was just one of the more obvious problems of estate management. In 1710 the Herveys had a walled kitchen garden laid out to feed themselves and their servants and estate workers. The lake was created in 1717 by damming the River Linnett. The walls now shelter a vineyard. (*Farringdon, Joe Wakerley, Bury Bookshop*)

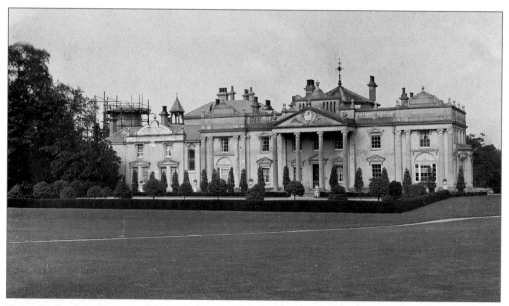

Great Saxham Hall was originally built for Thomas Eldred, an Elizabethan merchant. There is a tradition that it was called Nutmeg Hall, as he made his fortune trading in spices. In 1779 it burnt down. Hutchinson Mure, a Scottish amateur inventor and scientist, the then owner, designed a new house himself. He went bankrupt in 1793, partly because of expenditure on his schemes, and the next owner, Thomas Mills, finished it in a more restrained fashion. The surrounding park retains its eighteenth-century layout. (*Author's collection*)

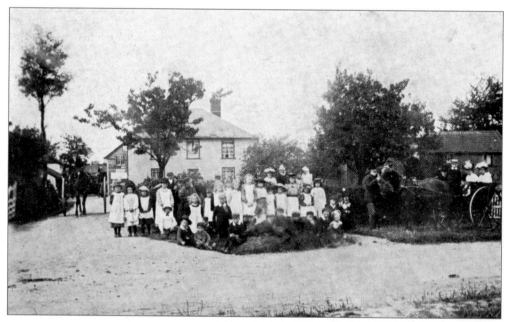

Hargrave Primitive Methodist Sunday School outing at Holly Bush House (now Bush House), probably photographed in 1904, and published in *West Suffolk Illustrated* (1907). Ann Philips who lived at Holly Bush House with her sister Susannah, married Hewson Ray, a Primitive Methodist preacher. Later their son Herbert ran a grocery shop in the village. A congregation met in a barn in the grounds of the house until 1926, when a chapel was built with money from Hewson Ray's will. (*Pawsey*)

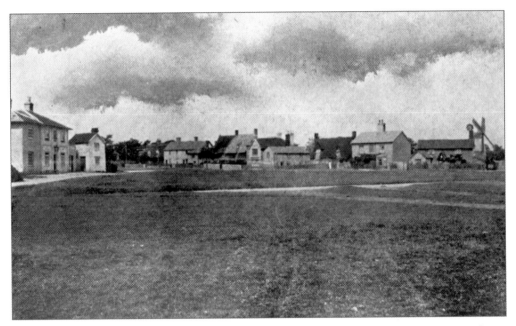

The large village of Barrow is centred on an extensive green. Its name is believed to derive from the Anglo-Saxon *barewe*, meaning wood or woodland. A fair used to be held on the green every first day of May. This was established by 1787, when the *Bury Post* reported that it was postponed because of an outbreak of disease, but it petered out in the twentieth century. (*Pawsey*)

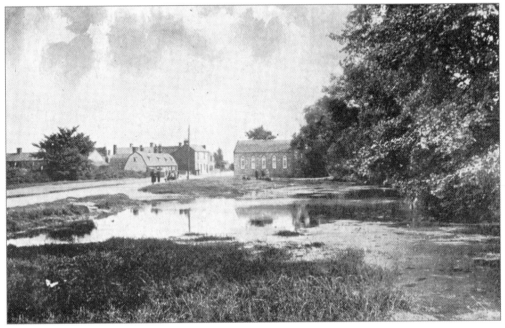

Britton's Pond, near Barrow green, as shown in *West Suffolk Illustrated* (1907). Then used to water horses, and clean carts and wagons, it is now home to a colony of ducks. The chapel was built for the Congregationalists in 1837. In 1851 it accommodated 140 people during its afternoon service. It was later used for Baptists, then Trinitarians, but Congregationalists later returned. It is now an Evangelical Free Church. (*Pawsey*)

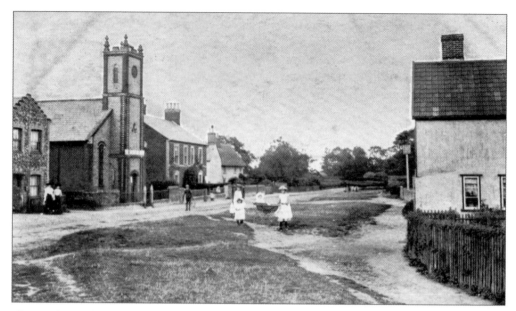

This rather eccentric structure beside Barrow green was built in 1869 as a Primitive Methodist chapel. By 1906 (the postmark date on the card) it had become a Salvation Army citadel (as advertised by the board over the entrance). When worship ceased the tower was preserved as it contained a public clock; although the clock has long since gone the tower is still a village landmark. This card was published by W.T. Barton, known locally as Brumbly Barton from his long beard, who was the village newsagent from 1896 to 1925. (*Joe Wakerley, Bury Bookshop*)

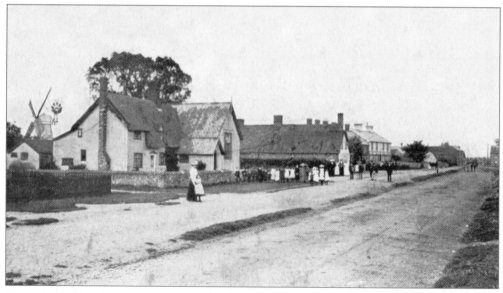

Barrow infants' school (foreground) opened in 1873; it included a teacher's house (left). It is now a nursery for pre-school children. The area left of the school was a waterlogged spot where willows grew but in 1953 the village hall was built here to commemorate the Coronation. The windmill is documented from 1824. By the 1920s it was owned by Mr King, a corn chandler. He could not compete with factory-milled flour, and in 1926 it was pulled down with cables drawn by a traction engine. This Barton card is postmarked 1905. (*Suffolk Jewellery and Antiques*)

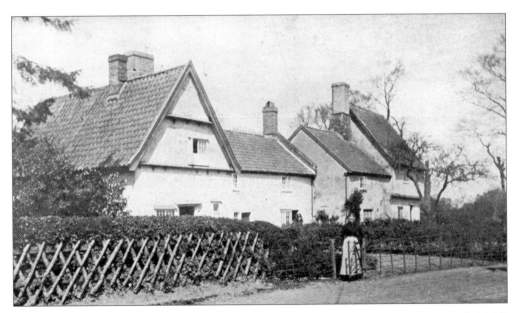

These buildings to the north of Denham village, photographed between 1903 and 1906, formed part of Denham End Farm. The two houses to the right still stand; fronted by attractive cottage gardens, they are believed to date from the sixteenth century. A note on the reverse says: 'Widow Brand at the door. Caroline at her gate.' Parish registers show that Caroline Everett married Alfred Sparrow in 1872, while Ann Brand's husband, William, died in 1888. The 1901 census records Caroline Everett and Ann Brand, then aged 48 and 72, living here. (*Pawsey*)

Dalham's name derives from the Anglo-Saxon *dale ham*: 'village in the dale'. Arthur Mee's 1941 guide to Suffolk in his *King's England* series described it as 'one of Suffolk's most charming villages, where thatched cottages look across the little River Kennett with its wooden bridges'. The bridges are now made of concrete. This postcard, published in about 1903, appears to show the Kennett in full flood, although this might be due to retouching. (*Pawsey*)

The Affleck Arms public house at Dalham (the Affleck family were lords of the manor between 1714 and 1900). The main road leading north from the village forded the village by the pub but now a concrete bridge has taken its place. (*Pawsey*)

The western end of Dalham High Street, as shown in *West Suffolk Illustrated* (1907). Most of the buildings and even the garden walls shown in this picture still stand. The peculiar circular building to the left was a malt kiln, and gives its name to the adjoining farm. (*Pawsey*)

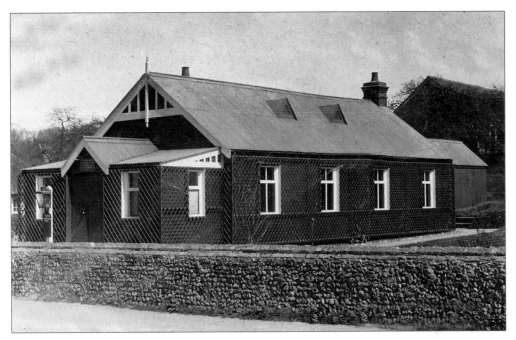

Dalham Village Institute and Reading Room. Cecil Rhodes, the South African magnate, bought Dalham from the Affleck family. He died in 1902 before he took residence. His brother, Frank, had this built as a village amenity and social centre in his memory. A good example of corrugated iron architecture, it is still a village hall. (*Farringdon, author's collection*)

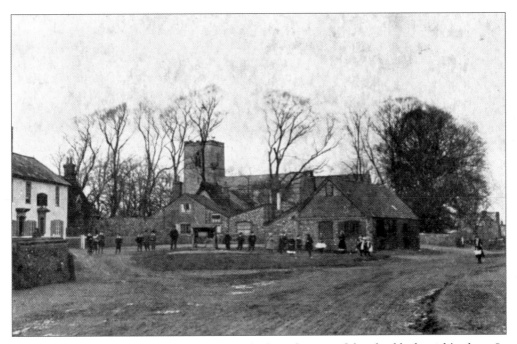

Gazeley focuses on a small village green, which is dominated by the blacksmith's shop. In 1906 the Alecock family owned it; by 1908 the Whitmore family had taken it over, but it had closed by 1916. Yet the smithy still stands, although empty and semi-derelict. The village well, to the left of the blacksmith's shop, was 183ft deep. The top was cemented over on 17 August 1949, but its position is still marked in the grass. (*Pawsey*)

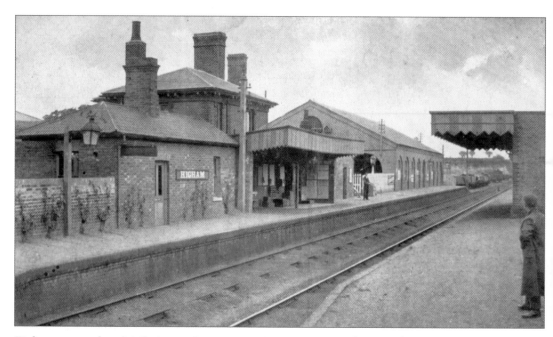

Higham was a hamlet that may have grown in importance after a railway station on the Bury–Newmarket line opened here on 1 April 1854. A church and school were built seven years later, and it became a separate parish in 1894. The 1901 census records Arthur Heavens, aged 38, as stationmaster; Amos Collier and Ernest Holsworth, aged 52 and 26, as signalmen, William Martin, aged 20, as a railway labourer, and George Buckle, aged 18, as porter at the station. The station closed on 2 January 1967, but some of the buildings survive. (*Pawsey*)

The approach to Higham station from the Bury–Newmarket road. The rectangular building to the right was a tollhouse, which charged tolls on people using the turnpike road that ran through here. The building to the left was a railway refreshment room, sometimes called the Seven Miles Tavern, as it stood roughly 7 miles from Newmarket and Bury. (*Pawsey*)

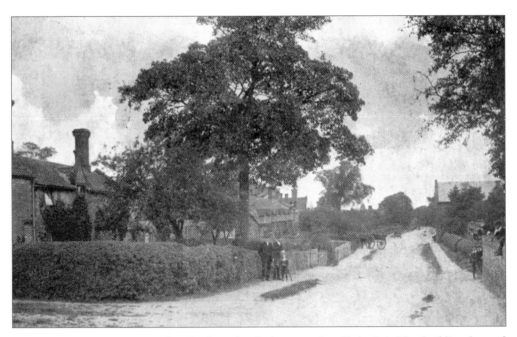

The main street at Higham, beside the school playground wall (right). The building beyond this, facing away from the road, was a Baptist chapel, built in 1838 and rebuilt in 1879. (*Pawsey*)

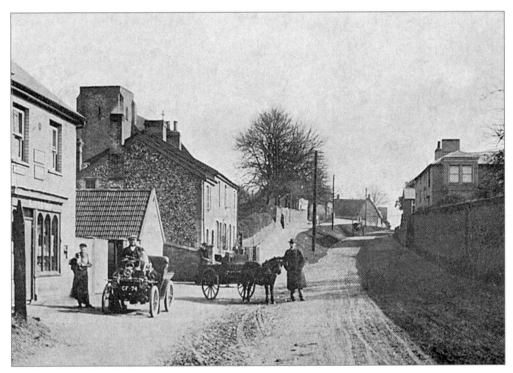

This view of Kentford, postmarked 1905, shows how the main road has been worn down well below the level of the church and the surrounding buildings. The photographer's car (shown in other Pawsey cards) stands in the foreground. Village tradition holds that the man jokingly sitting in the car was Mr Norman, postmaster at the village post office (left). (*Pawsey*)

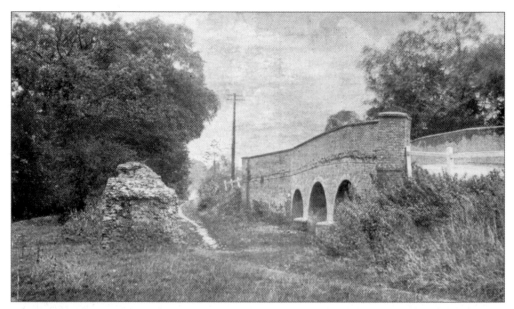

A fragment of an early bridge over the River Kennett at Kentford on the Suffolk-Cambridgeshire county boundary. Like many such bridges, it ran alongside a ford. Mentioned in Richard Haddenham's will in 1542, and called The Old Bridge in 1797, *West Suffolk Illustrated* (1907) described the remains as Roman. It was more likely that it was a fifteenth-century structure, similar to that at Moulton. The remains were destroyed by winter flooding in the 1970s. The modern bridge beside it was replaced in 1920. The new bridge was widened in 1948, and upgraded to support 90 tonnes in 1999. (*Pawsey*)

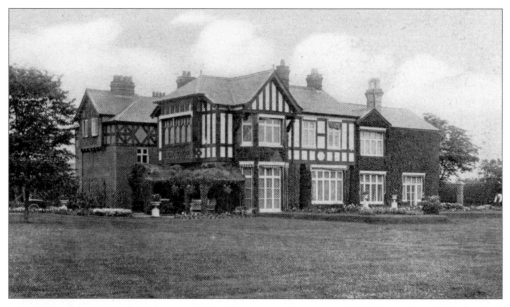

Regal Lodge at Kentford, built in about 1850, is a good example of a house built for the racehorsing fraternity in the Newmarket area. Its first owner was George Algernon Baird, a trainer. Lillie Langtry, the actress, artist's model and socialite, later acquired it. Lillie Langtry became mistress to the Prince of Wales (later Edward VII) who often visited her here. In 1985 it became the Langtry Hotel (Lillie's bedroom being a special suite) but it was divided into apartments in 1990. (*Pawsey, author's collection*)

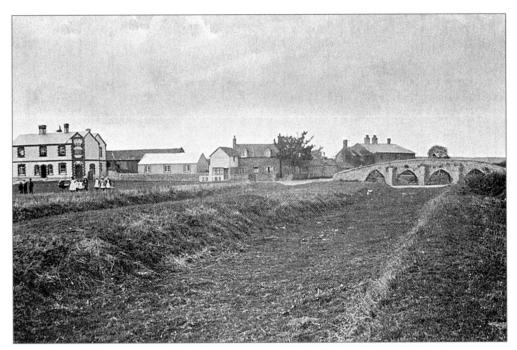

Moulton village green with the River Kennett in about 1903. The bridge in the background was built in the fifteenth century. Traditionally called the Packhorse Bridge (from horses that would have crossed it), it is in fact wide enough for a cart to cross. Although the river is dry here, it was still liable to flood in winter at the start of the twentieth century. (*Pawsey*)

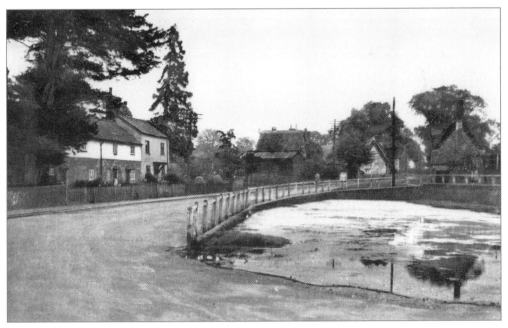

Ashley village pond, facing east, 1929. The pond is the focal point of the village. The brick wall surround might be of seventeenth-century construction. Modern drains now surround the pond, diverting water away. In the past few years the water level has been allowed to fall dangerously low. Grass and trees are now grown beside it. Unless action is taken, Ashley could lose its pond. (*Halliday, author's collection*)

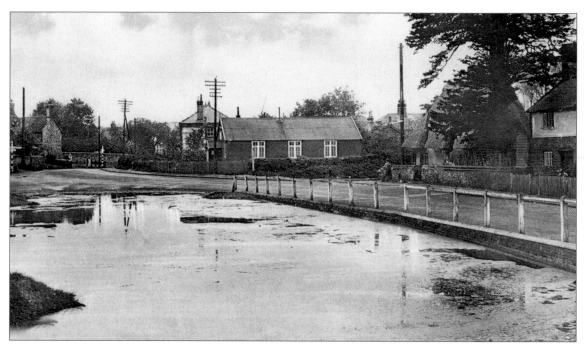

Ashley village pond facing west, 1929. The corrugated-iron structure was built as a Methodist chapel in 1891 to accommodate a congregation of 125. An interesting example of the so-called tin chapels that were not uncommon at the time, it was closed in 1980 and demolished several years later. Note the extent of the village pond. (*Halliday*)

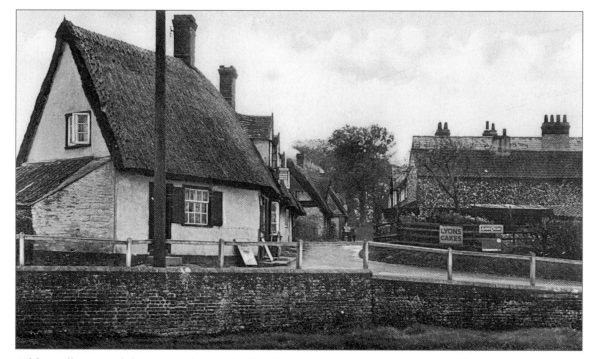

Ashley village pond facing north, 1929. The thatched terrace may have dated from the seventeenth century: it was allowed to become derelict and was recently demolished, to be replaced with houses of similar design. (*Halliday: his first photograph*)

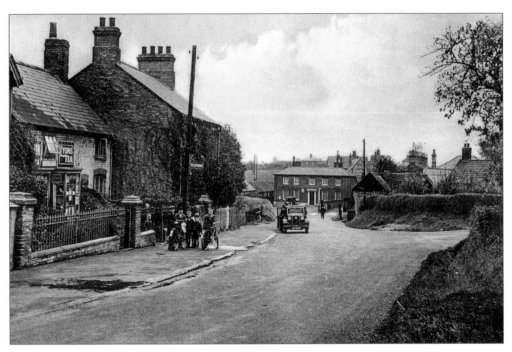

Ashley High Street showing the shop and post office (left), 1929. The village green, which extended from the right of the road, was built over in Victorian times. The Crown, the Victorian village pub, stands behind the car; the village school is just visible over this (right behind far telegraph pole). (*Halliday*)

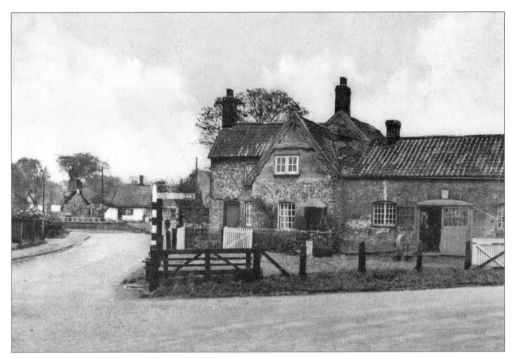

Ashley blacksmith's shop was built in 1869 on the site of an older smithy; its interior incorporates medieval carved stonework. After the Second World War it became a garage, but it has recently been turned over to residential use. (*Halliday*)

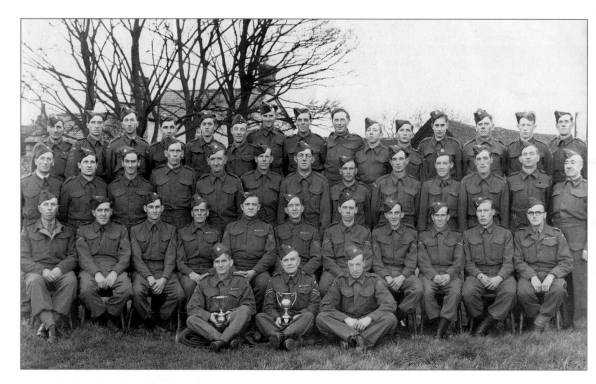

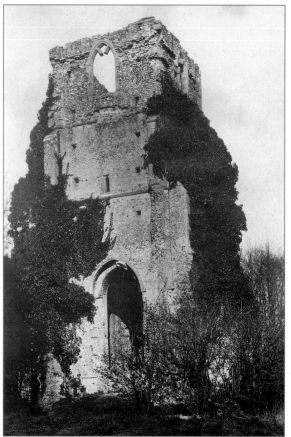

The Ashley Home Guard platoon. Back row, left to right: Cecil (Gibb) Langley, John (Rusty) Burrows, Bob Murton, Robert Turner, Cecil (Jimmy) Smith, Tom Iason, Will Shelbourn, John Taylor, 'Roper' Ransome, Walter Aldous, Jack Kerry, Maurice Holmes, Henry (General) Smith, George (Wanty) Kerry, Fred Vince. Third row: Frederick Mayes, Owen Halliday (author's father), Harold (Hector) Smith, Arthur Cater, Jim Bell, Mr Bird, Bill Challice, Charles Mayes, Jack Turner, Arthur (Yotty) Burrows, K. Waddy, Ernest (Toby) Burrows, Robert Claydon. Second row: George Smith, Pat Jennings, Bert Rosbrook, Alan Langley, Reuben Daines, Jack Copping, Jim Claydon, George Langley, Leslie Knights, Derek Copping, Mr Pledger. Front row: Mr Davey, Peter Smith, Arthur Edwards.

The trophies were probably for riflemanship and shooting. (*Mr and Mrs J. Smith*)

Silverley tower or steeple, 1925. Silverley village was in the Domesday Book, but settlement moved towards Ashley in the thirteenth century, leaving the church in isolation. Still in use in 1562, it had become a barn by 1586, and had fallen into ruin by 1705. Luckily saved from demolition in 1971, the tower now stands in a wood by a road junction. (*Author's collection*)

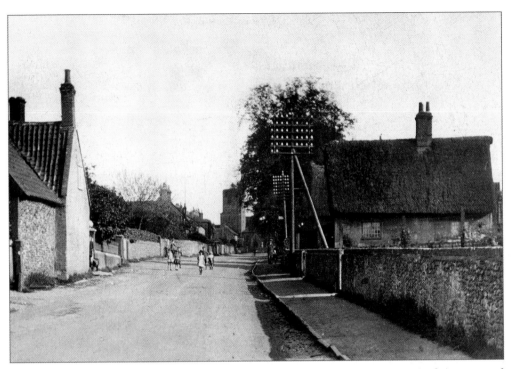

Cheveley High Street facing north, on a card postmarked 1927. The opening (right) contained a water point. The formidable telegraph poles were once a familiar item of street furniture. (*Author's collection*)

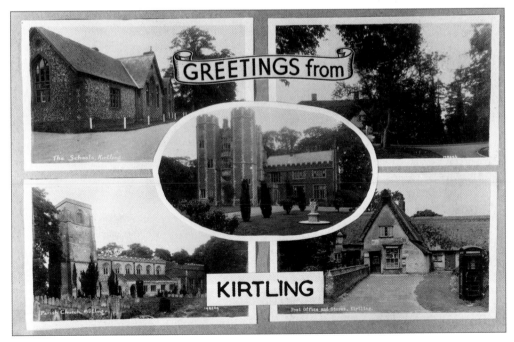

A composite postcard of Kirtling published in the 1920s showing (clockwise from top left) the school, the Queen's Head, the post office, and the church. The building in the central oval is Kirtling Tower, a gatehouse that is the surviving fragment of a Tudor mansion built for the North family (whose tombs fill the church). (*Author's collection*)

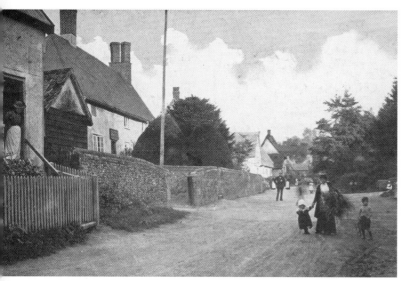

Lidgate. The Street, showing the Star (left of flagpole), from a card postmarked 1908. A woman walking along the street carries a large bundle of brushwood. (*Pawsey*)

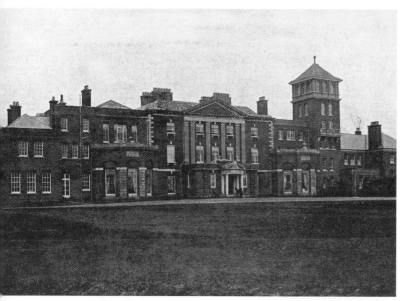

Branches Park, Cowlinge, as shown in *West Suffolk Illustrated* (1907). The central block was built for Francis Dickin, an eighteenth-century lawyer and wings were added in the nine-teenth and early twentieth centuries. It was bought in 1946 by Rachel Parsons, who in later life became mean and unpleasant to everybody, and refused to pay her employees. In 1956 one worker, desperate for money to support his family, battered her to death after being abused by her. He was imprisoned for manslaughter, the court believing Rachel to have been unreasonable. By then, she had so neglected Branches Park that it was uninhabitable and had to be demolished. (*Pawsey*)

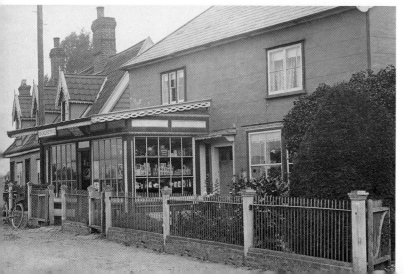

Cowlinge post office, on a card postmarked 1912. Soon after the First World War this was taken over by the Foreman family, who ran it until 1990, continuing to use hand-cranked petrol pumps. (*Farringdon, Suffolk Jewellery and Antiques*)

A corner of Denston village green, 1930s. These attractive buildings, known as Sunnyside, may have dated from the mid-seventeenth century. The cottage facing the road disappeared many years ago, possibly burnt down, but Denston still retains many other similarly attractive cottages. (*Joe Wakerley, Bury Bookshop*)

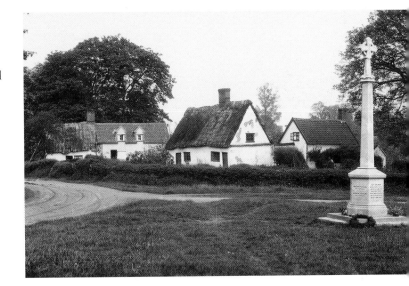

Bridge Cottage at Denston, by a bridge over the river, might date from the late sixteenth century. It was once a gamekeeper's house, and called Keeper's Cottage. (*Suffolk Jewellery and Antiques*)

Settlement in Wickhambrook, one of Suffolk's largest parishes, spreads over nine greens: Ashfield (or Aldersfield), Attleton, Baxter's, Coltsfoot (or Colts Cross), Farley, Genesis, Ladies, Meeting and Nunnery Greens; and six other settlements – Thorns Corner, Boydon End, Clopton Hamlet, The Duddery, Maltings End and Wickham Street. This postcard of Coltsfoot Green was published in about 1903. The 1884 Ordnance Survey map shows a brickworks and allotments near this settlement. A brook still runs across the green. (*Pawsey*)

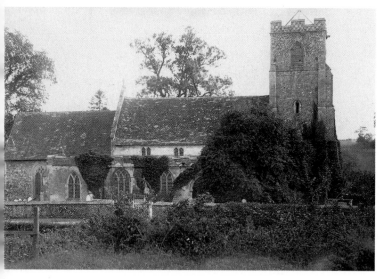

All Saints' Church, Wickhambrook, shortly before the First World War. *In the Golden Days*, by Edna Lyall, a Civil War romance, was a best-selling historical novel in Victorian times. Much of the action takes place in Wickhambrook (renamed Mondisfield) and one chapter is set in the church. As in so many villages in Suffolk, the church needs continual maintenance, and the parishioners are engaged in a fund-raising campaign to safeguard All Saints' for the future. (*Farringdon*)

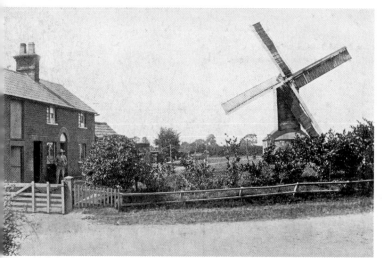

Bullock's Mill at Thorn's Corner, one of the highest points in Wickhambrook. The postcard was published in about 1903. Charles Bullock, the miller, stands in the doorway of the miller's house. The mill was demolished in 1909. There was a well near the mill, which was said to never run out, even in the worst drought. (*Pawsey*)

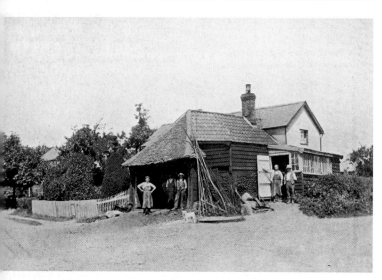

Wickhambrook blacksmith's shop (now demolished) also stood at Thorn's Corner. Alfred Hicks, the blacksmith, stands to the left of the smithy entrance in his apron. The man to the right, with his hand on the door, is A.G. Hurrell, a Methodist lay preacher. (*Pawsey*)

This rather solidly built chapel was built at Thorn's Corner for the Primitive Methodists in 1850, to accommodate 500 people. At that time it attracted a congregation of 165 people in the morning, 420 in the afternoon and 266 in the evening, probably more than the parish church. It continues to serve local Methodists. (*Farringdon*)

The Plumber's Arms, Wickhambrook, was built on Wickham Street on the main Bury–Haverhill road in the early nineteenth century. It was a commercial hotel, catering for horse-drawn travellers. The parish boundary ran through the pub, with the result that half the building stood in Denston, but since boundary changes in 1982 it has stood wholly in Wickhambrook. Notice the stone to the right of the door; a glacial erratic weighing several hundredweight, its purpose is uncertain. (*Pawsey*)

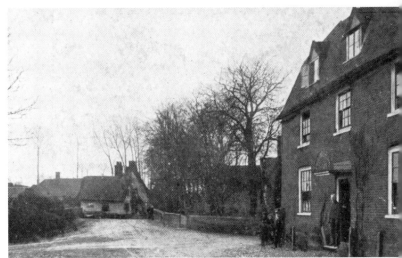

Gifford's Hall: a moated manor house, built in about 1480 by the Heigham family, members of whom are buried in Wickhambrook parish church. This declined in use to being a farmhouse, but was bought in 1904 by Seymour Lucas RA, who had the house beautifully restored.

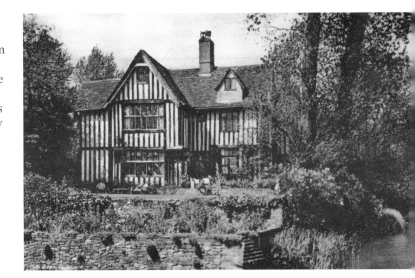

Hundon High Street, postmarked 1927. The building to the near left was built as a Congregational chapel in 1846, and is now a private house. The row of houses on the right were formerly a workhouse. (*Author's collection*)

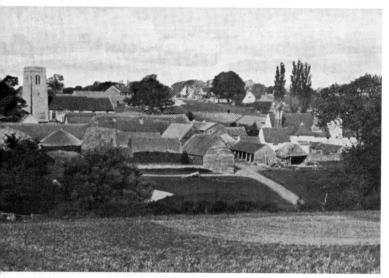

This view of Hawkedon, from *West Suffolk Illustrated* (1907), is still inspiring. In 1941 Arthur Mee wrote in his guide to Suffolk in the King's England series: 'we may look down on it from sloping fields and see the landscape with fair cottages and barns and haystacks huddled together, and a little fifteenth-century church standing boldly on the green, watching over all'. The church is mentioned in the Domesday Book; in 1452 John Hucton left 14s to 'the joint work of the church', suggesting that it was being rebuilt then. (*Pawsey*)

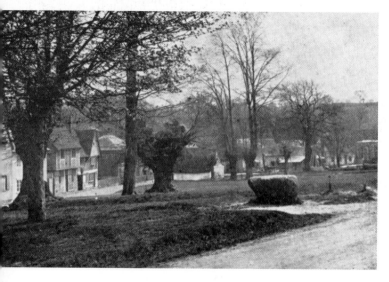

A little-known gem of the Suffolk countryside, Hartest contains as good a selection of historic buildings and attractive landscapes as any village in the county. This view, from *West Suffolk Illustrated* (1907), shows a glacial erratic stone. Local traditions say that forty horses pulled it from the neighbouring parish of Somerton in 1713 to celebrate the end of the War of the Spanish Succession; and that the villagers held a festival around it to celebrate George III's recovery from insanity in 1789, starting an annual fair that continued until the 1950s. (*Pawsey*)

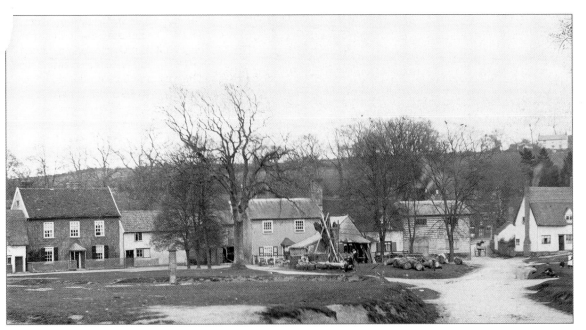

Hartest village green, facing north-west, on a card postmarked 1904. The timber structure on the green was the wheelwright's sawpit. There is a depression on its site. The timber building right of this was a coal warehouse and is now a house. In the seventeenth century Hartest was an outlying centre of the south-west Suffolk clothing industry: the street running down from the right of the coal warehouse is known as The Duddery, from clothes that were made and sold there. Hartest lies in some unusually hilly countryside for Suffolk, as shown by the high ridge in the background. (*Joe Wakerley, Bury Bookshop*)

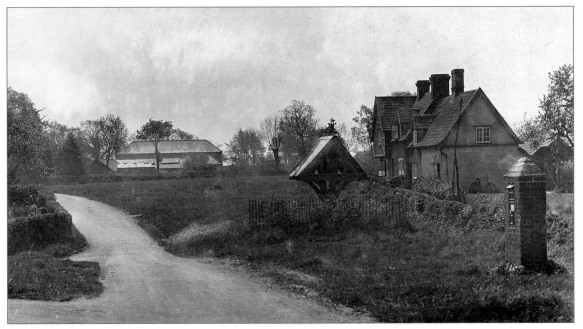

The green at the south of Lawshall. Drake's Well was made by the Tyrwhitt-Drake family, who lived at Thorne Court (over the parish boundary in Shimpling), in memory of Charles Frederick Tyrwhitt-Drake, who died in Jerusalem on 23 June 1873. In 1976 the villagers banded together to restore it. (*Joe Wakerley, Bury Bookshop*)

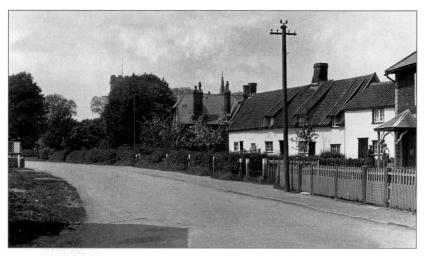

The Street at Lawshall, facing north. One of the cottages in the centre of the picture is called Pantile Cottage, presumably from its roof. (*Joe Wakerley, Bury Bookshop*)

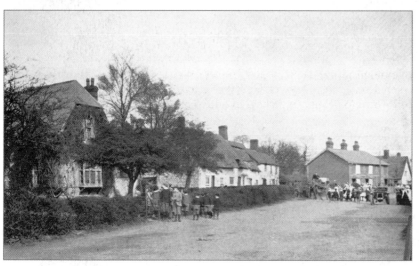

The Street at Lawshall, facing south, *c.* 1903. The building in the left foreground (at right angles to the street) is the village school, built in 1871 and still in use today. Frederick Pawsey and his photographer have left their transport at the end of the street: it seems to be causing something of a commotion! (*Pawsey*)

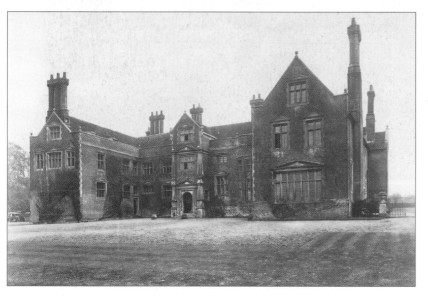

Robert Rookwood built Coldham Hall, between Lawshall and Stanning-field, in 1574. Robert was a wealthy Roman Catholic landowner, and his son Ambrose was one of the Gunpowder Plot conspirators of 1605. Legend holds that a curse will be released if two portraits of a nun and a mother superior displayed on the walls are moved, and that the ghost of a young nun called Penelope haunts the Hall. (*Pawsey, Joe Wakerley, Bury Bookshop*)

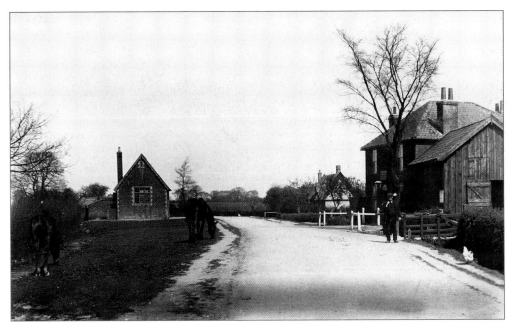

The Red House Inn at Stanningfield (right), so named because it was made from red bricks, was built in 1865. The small building to the left was the village school. Built in 1875 by subscription, it merged with Great Whelnetham School in 1935 and was later demolished. (*Joe Wakerley, Bury Bookshop*)

Chadacre Hall at Shimpling was built between 1823 and 1834 for Thomas Hallifax, a London goldsmith. After the First World War the Earl of Iveagh converted it into an agricultural institute for young men. The buildings in the left foreground were added for educational purposes. The 1954 prospectus shows that students woke at 5.30 a.m. and worked or studied until 5.15 p.m. (with meal breaks), with lights out at 9.30. Recreation consisted of rugby, two afternoons a week! The institute closed in 1988 as fewer people were working in agriculture. (*Author's collection*)

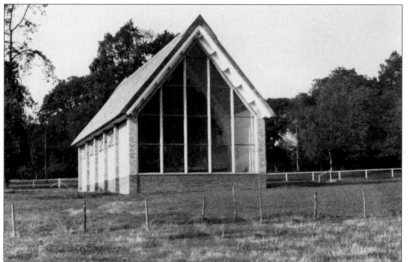

The chapel at Chadacre Hall was financed by a gift from the Earl of Iveagh (then aged 92) in 1965 and dedicated on 21 October 1966. Built for interdenominational services, it was an example of the more modest church architecture of the time but was demolished after the Institute closed. (*Author's collection*)

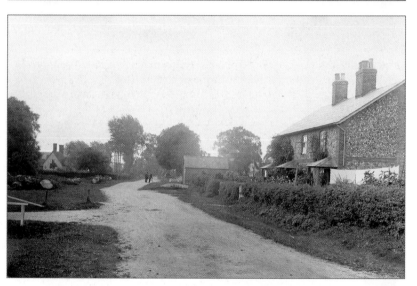

Shimpling Street, postmarked 1909. The house in the foreground has recently been extended sympathetically. The one-storey building on the right side of the road was built as a coalhouse in 1861. (*Joe Wakerley, Bury Bookshop*)

This postcard of Bay Tree House in Shimpling High Street presents an idyllic picture of a Suffolk cottage garden. At the time it was occupied by Mr Dye, a chimney sweep. Bay Tree House now has a tile roof, but the bay tree still grows transplanted to another spot in the garden. (*Joe Wakerley, Bury Bookshop*)